The Photographer's Guide to
Composition

The Photographer's Guide to
Composition

John Freeman

COLLINS & BROWN

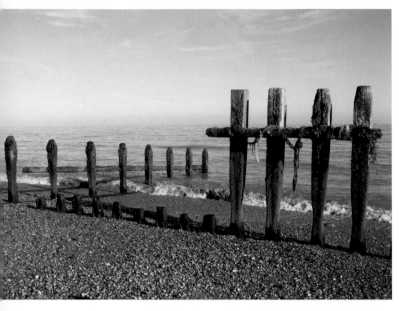

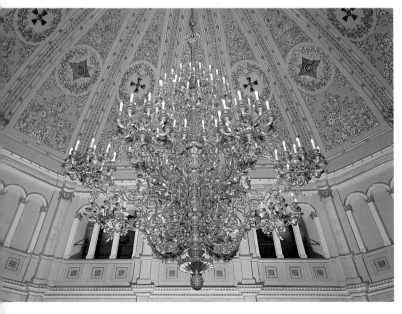

For my nephew, Alex

First published in Great Britain in 2004 by
Collins & Brown Limited

An imprint of **Chrysalis** Books Group plc

The Chrysalis Building
Bramley Road
London W10 6SP

Distributed in the United States and Canada by
Sterling Publishing Co., 387 Park Avenue South,
New York, NY 10016, USA

1 3 5 7 9 8 6 4 2

British Library Cataloguing-in-Publication Data:
A catalogue record for this book is available from the British
Library.

ISBN 1 84340 170 3

Commissioning Editor: Emma Baxter
Copy Editor: Ian Kearey
Design: Grade Design Consultants
Digital Systems Operator: Alex Dow
Project Editor: Serena Webb

Reproduction by Mission Productions Ltd, Hong Kong
Printed and bound in Times Offset (M), Sdn. Bhd, Malaysia

Contents

Introduction

Probably the biggest single flaw in many people's photographs is the lack of thought paid to composition. For instance, how many times have you been shown a photograph of a landscape where a featureless sky dominates the print so that the foreground becomes lost and insignificant, or a portrait where a person has been placed so far away from the camera viewpoint that it takes a while to realize that they are there at all?

The main reason why these errors occur time and time again is that the majority of photographs are taken as quickly as possible, with very little thought paid to viewpoint, foreground, background, depth of field or framing. Mention these basic areas to a group of aspiring photographers, and the majority will look stunned and probably say that they could never memorize such a long list; all they want is a "good" photograph, not a work of art! Ironically, a "good" photograph *is* a work of art and, like all art, photography needs to be practised and worked on until you get it right.

Once you decide that you want your photography to be that much better and start thinking about the areas mentioned above, it's amazing how quickly all of them become second nature, and you almost start to take photographs without being aware that you are implementing these basic rules. Consider driving a car: when you are learning and have only driven a few times, there is a tendency to look down at the gear column when changing gear. However, after a few months, when you have gained experience, do you ever look at the gear column again? The answer is "No, never", and the same is true in

photography – if you get used to following a few basic rules, they soon become second nature, and you can then get on with the job of looking at different ways of seeing potentially good photographs.

A rule that artists have followed since the Egyptians built the pyramids and the Greeks constructed fabulously beautifully proportioned buildings, such as the Acropolis, is known as the Golden Section. What this rule means is that the subject should stand at the intersection of imaginary lines drawn vertically and horizontally a third of the way along the sides of the picture. Of course there are many photographs that completely reject this rule and are still fine examples of good composition. What you should aim for is to draw the viewer's eye to the main subject by using strong perspective, or the contrast of the subject with the background, or the distribution of various hues of colour, or a combination of all of these.

Many professional cameras have interchangeable focusing screens, one of which is known as a grid screen. With this, when you look in the viewfinder the horizontal and vertical lines you see can be a great aid when it comes to framing and composing your picture. Of course, these lines do not appear on your finished photograph.

Once you become more confident with your equipment, you have more time to look at a potential photograph, as you are not fumbling with the controls on your camera. It is the time you take in looking that reflects in your photography. Questions you should start to ask yourself are: would this shot look better from a lower viewpoint, or do I need to find a higher vantage

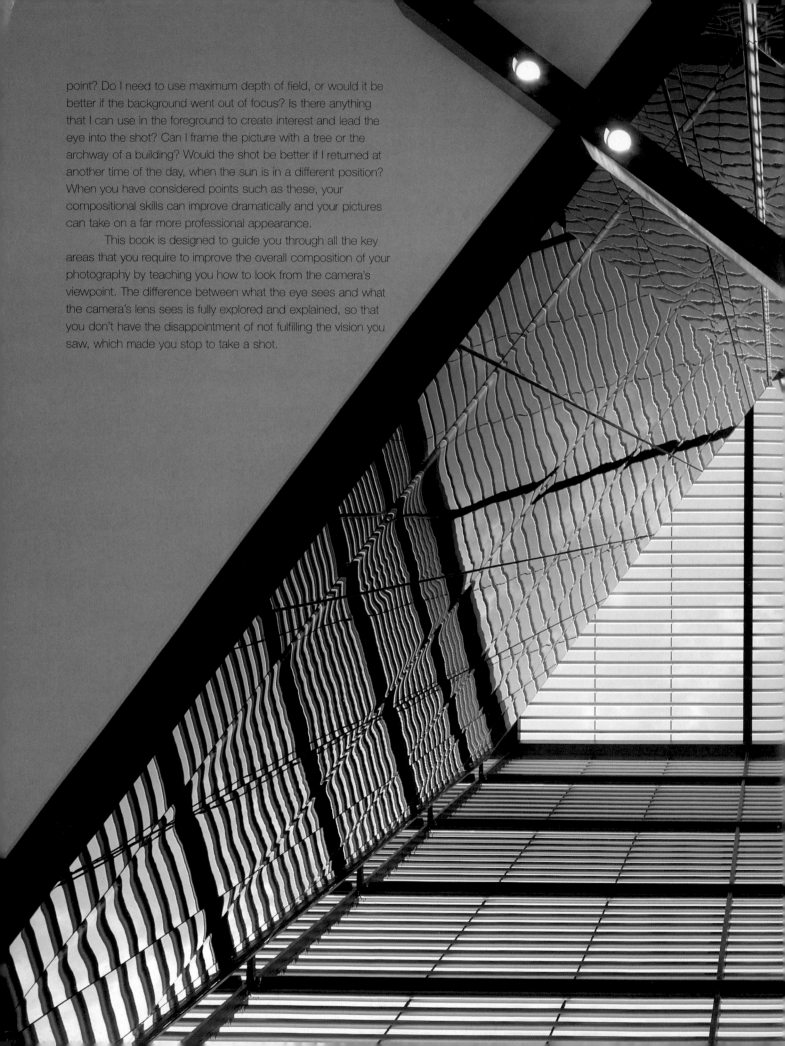

point? Do I need to use maximum depth of field, or would it be better if the background went out of focus? Is there anything that I can use in the foreground to create interest and lead the eye into the shot? Can I frame the picture with a tree or the archway of a building? Would the shot be better if I returned at another time of the day, when the sun is in a different position? When you have considered points such as these, your compositional skills can improve dramatically and your pictures can take on a far more professional appearance.

This book is designed to guide you through all the key areas that you require to improve the overall composition of your photography by teaching you how to look from the camera's viewpoint. The difference between what the eye sees and what the camera's lens sees is fully explored and explained, so that you don't have the disappointment of not fulfilling the vision you saw, which made you stop to take a shot.

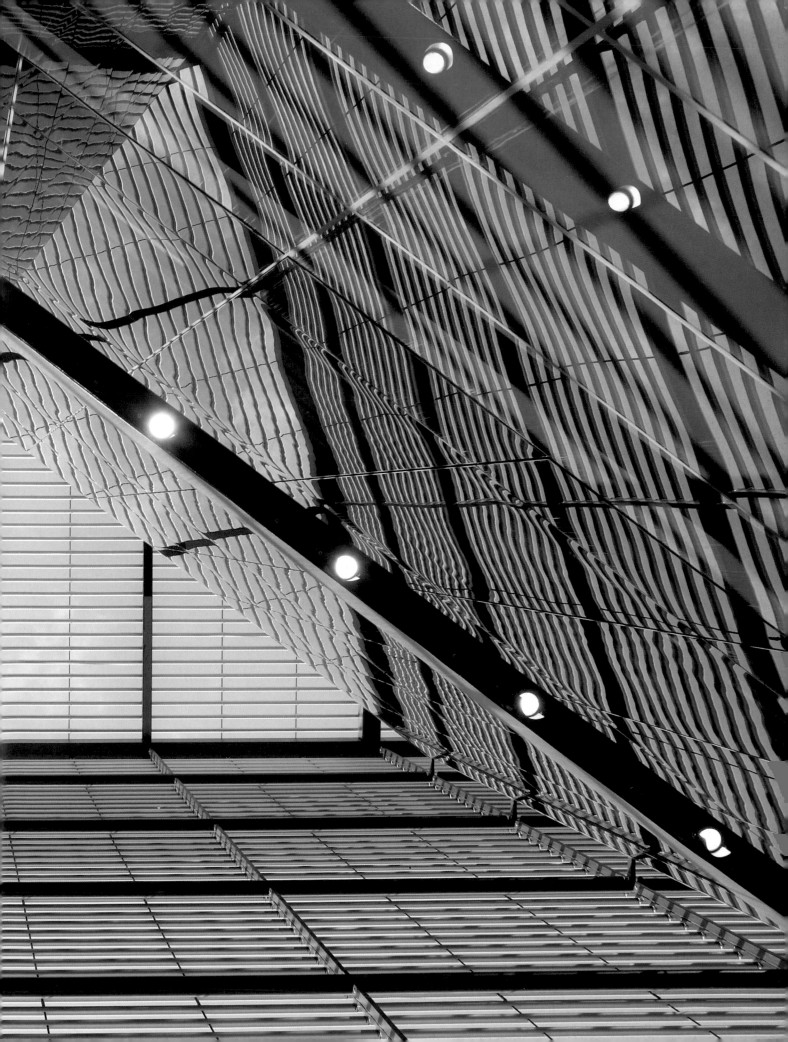

The Essentials

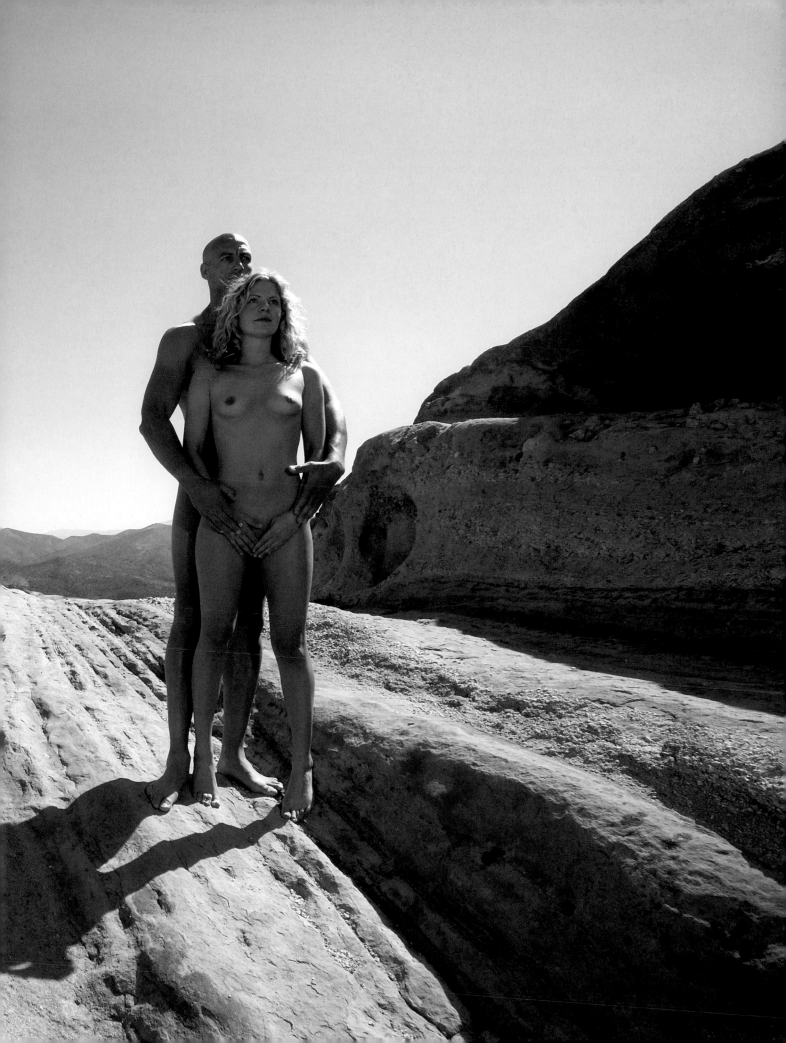

Basic Equipment

Although there isn't one single piece of equipment that can give you perfectly composed pictures every time, there are ways to use your camera and lenses to produce more effective results. The important point to remember is that, even with the most expensive camera, the most advanced lens or the latest digital technique, your photographs can only ever be as good as the way you see a picture and then get your equipment to interpret it.

One of the biggest assets of the digital age is the LCD (liquid crystal display) screen. With this you can view and frame your picture, knowing that what is displayed is what will come out in your final photographs. This has the distinct advantage over the more traditional eye-level viewfinder, in that it dispenses with the age-old problem of parallax error. This arises because the viewfinder sees a slightly different view to that of the taking lens; the effect becomes more apparent when working at short distances. An adjustment has to be made to allow for this disparity, known as "parallax correction". Without this correction, it is probable that when you view your finished shots a large proportion of your subject is cut out of the frame.

The only other cameras where parallax is not a problem are SLR (single lens reflex) cameras and view cameras, or technical cameras, as they are sometimes called. Being able to view your subject as accurately as possible is a major step in helping you compose better pictures.

The range of cameras, both film and digital, now on the market is truly phenomenal. SLR cameras are the most versatile models available, and the more serious you are about your photography, the more likely you are to aspire to one of these. The film range is enormous, and more and more digital models are becoming available.

What makes this type of camera so enviable is the vast range of lenses and accessories available. Because of this, SLRs are sometimes referred to as "system" cameras. Depending on the manufacturer, there are lenses from fish-eye to ultra-telephoto, with macro, shift and tilt, converters and many zoom lenses in between. Extension tubes and bellows, dedicated flashguns, right-angle viewfinders, different focusing screens and remote controls are just some of the accessories that you can use.

1

If your camera allows you to change the focusing screen, it might be beneficial to fit a "grid" screen. As the name implies, thin lines that run horizontally and vertically across the focusing screen are visible when you look through the viewfinder. (Obviously these do not appear on your photographs.) The grid lines are invaluable for accurate positioning of your subject in the frame, and can help in composing pictures based on the rule known as the Golden Section (see page 38). They are also useful when it comes to making sure that vertical aspects of your picture are completely vertical, or that the horizontal planes of your picture are level.

If your camera comes with a zoom lens as standard, you can choose the desired focal length with greater accuracy when using an SLR or the LCD screen on your digital camera. It is important to remember, though, that using the LCD screen as your main viewfinder can drain the battery very quickly, which can be a real nuisance if you are just about to take a vital shot. Even if you have a back-up battery, the moment can easily pass and the shot can be gone forever by the time you change it. Of course this is not a problem with SLR cameras, as you do

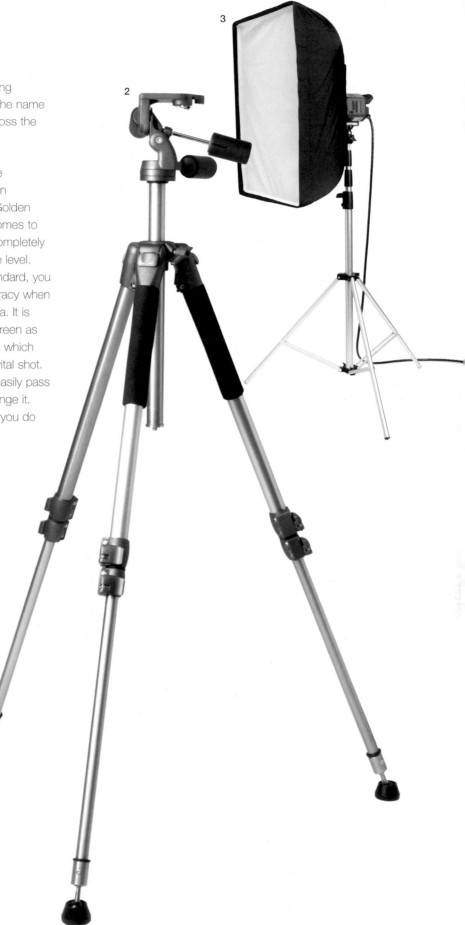

1. Medium-format camera with interchangeable digital and film backs.
2. Tripod.
3. Monobloc flash unit

Basic Equipment continued

not use the LCD as the viewfinder. The LCD is there for you to review your shots and to check on the exposure, sharpness and composition. You can also edit and delete your shots as you go, thus saving space on your compact flash card.

Another benefit of SLR cameras is that they come with a depth-of-field preview (see page 22) This enables you to see exactly how much of your picture will be sharp, even before you have taken it, thus greatly improving your ability to compose your shots correctly.

The greater the range of lenses or the power of your zoom lens, the greater is your control over the final composition of your picture. A great combination of lenses is a 17–35mm, a 28–70mm and a 70–200mm zoom. These three lenses provide the focal lengths for just about any shooting situation, and if you also purchase a 2x extender, so that your 200mm becomes a 400mm, you are unlikely to need any other lens.

When purchasing any lens, always try to buy one with the fastest aperture you can afford: for example, a 28–70mm zoom lens that has a widest aperture of f2.8 throughout its range is much more versatile than one that goes from f3.5 at 28mm to perhaps f5.6 at 70mm, enabling you to shoot in lower light conditions – and the optics are also of a higher quality. However, the difference in technology required to achieve this increase in quality comes at a price, which can be considerable with some lenses.

Another important point to consider with zoom lenses when purchasing a digital camera are the terms "digital zoom" and "optical zoom". With the former, the camera enlarges part of the image to give the illusion of zooming in, but this could be done on a computer after the shot has been taken. If you try to enlarge the image subsequently the quality will be greatly diminished. An optical zoom actually brings your subject closer and you can then crop into the image without the same loss of definition. The only aspect that you should consider when comparing different models is the power of the optical zoom. The greater the range of the optical zoom, the more costly the equipment will be, so it might be worth considering the purchase of wide-angle or telephoto adapters. These fit on to the front of a standard camera lens and give a greater range of focal lengths.

Whatever equipment you ultimately choose, the important aspect is to get to know it so well that it will become second nature to you. Composition is about seeing and interpreting. The more familiar you are with your camera, the more you will be able to concentrate on seeing.

1. Graduated neutral density filter.
2. Screw-in filters.
3. Compact flash cards.
4. Interchangeable lenses.
5. Flashgun.
6. Extension tubes.
7. Shift and tilt (PC) lens.

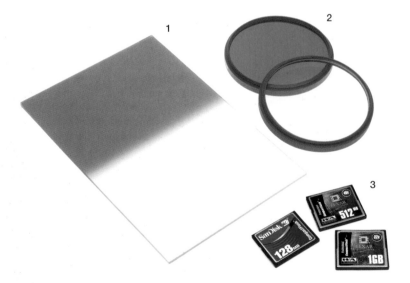

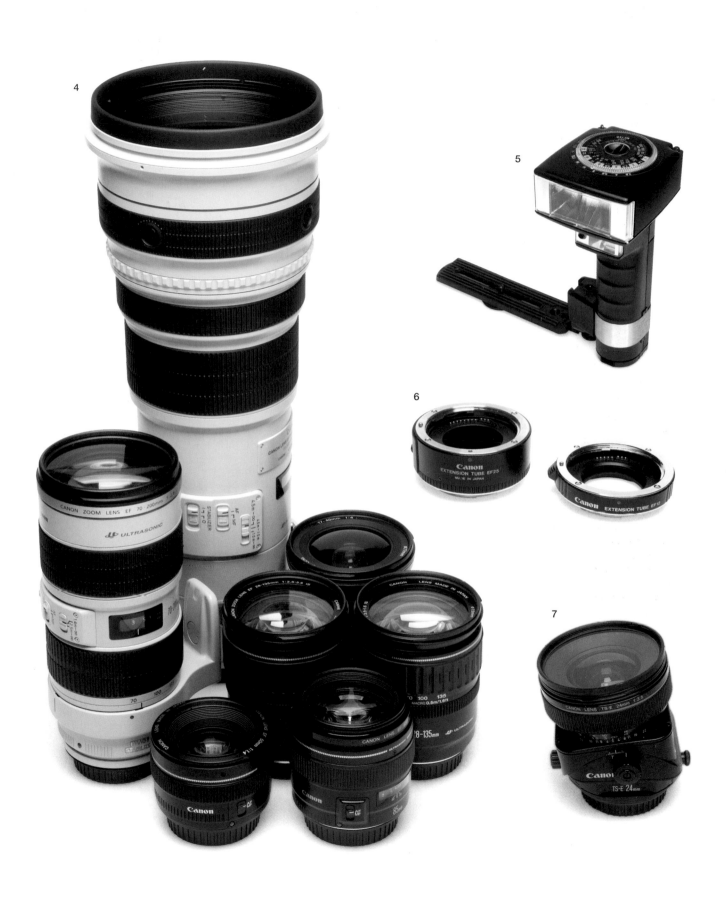

How the Eye Sees and How the Camera Sees

The reason why many photographs fail is because people assume that what they see with their eyes will come out in the same way once they have pressed the shutter release button on their camera. Nothing could be further from the truth. Unlike cameras and their lenses, our eyes (or, more accurately, our brains) constantly evaluate and edit our vision, eliminating any unwanted distractions. Cameras can only do this with our help, which is why you should know exactly how your equipment really works, and understand its limitations.

Consider something that you look at every day and take for granted – a favourite picture hanging on your living room wall, or a television, for example. It would be rare to find a situation where the picture or the television is against a completely white wall devoid of any other ornaments, plants, shelves, other pictures, a door or window. Even if this were the case when looking at a television, chances are that there would be a video or DVD recorder nearby. Now, when you look at the television or picture, these other items do not disappear, but your brain

"pushes" them into the background so that they are no longer a distraction to what your eyes are concentrating on. If you were to take a photograph from your normal viewing position all the surrounding detail would be just as clear as the television or picture when you view the finished print. The camera would not have made the surrounding details disappear in the same way that your brain would have done. This is because no matter how sophisticated cameras become, they cannot eliminate unwanted detail if it is more or less on the same plane as the main subject.

Try this simple test: look at the television or picture from your normal viewing position. Although your peripheral vision makes you aware of other objects, nothing distracts from your main area of focus – the television or picture. The only way you are going to see these other objects is to re-focus on them. When you do this, the television or picture gets pushed into the background. For the photographer, the only way to eliminate these distractions successfully is to change position and find another viewpoint to achieve a more pleasing composition.

Below and below right: Unlike the brain, the camera cannot eliminate unwanted detail. In the picture below, not only is the television visible and clear, but so is everything that surrounds it is as well. When we watch television, our brain concentrates on that and that alone. Other objects that surround the television become blurred, and the screen seems to be larger than it really is (below right).

Opposite above: Often when we look at a scene, certain sights are too far away for our eyes to properly focus on them (above left), and no matter how much we strain, they are not going to become any clearer or nearer. The advantage that cameras have, in this case, is that they can be adapted to bring distant objects closer so that we can see them in greater detail (above right).

Opposite below: There are times when we want to see more in our pictures than it is possible to see with our eyes. It is easy to concentrate on the spring onions (below left) in much the same way that our eyes would see them. Changing to a wide-angle lens (below right) means we can see much more than we could with our eyes because the picture is sharp all over.

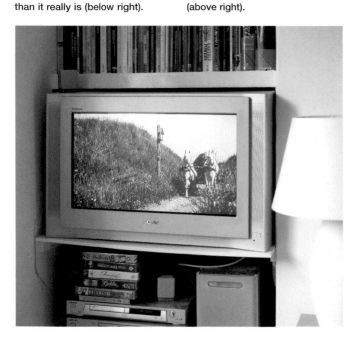

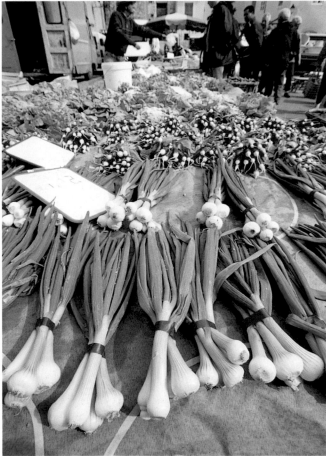
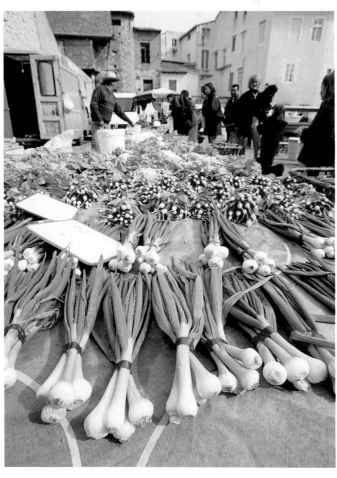

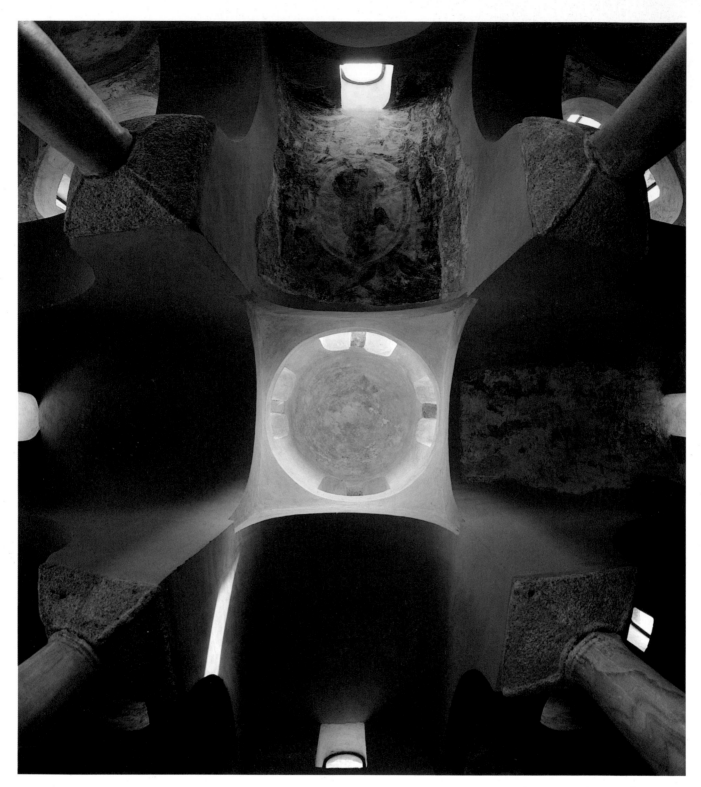

Above: One of the things our eyes can never do is have the angle of view of a fish-eye lens. In this shot the angle of view is almost 180°, compared to that of the human eye, which is about 50°. With this lens the depth of field is enormous, even when set at its maximum aperture.

Opposite: In these shots we can see how different focal lengths can progressively alter depth. In (1) a 17mm lens was used. Apart from taking in a wide field of view, the posts are spread out and the distance between each one looks far greater than it actually is. In (2) a 50mm lens was used, this gives roughly the same angle of view as the human eye.

In (3) the lens was changed to 100mm, which slightly compressed the distance between the posts, and this compression is even greater in (4), taken with a 200mm lens. In (5), taken with a 400mm lens, the distance between the posts looks far less than in reality, to the extent that they are almost touching one another, thus completely altering the overall composition.

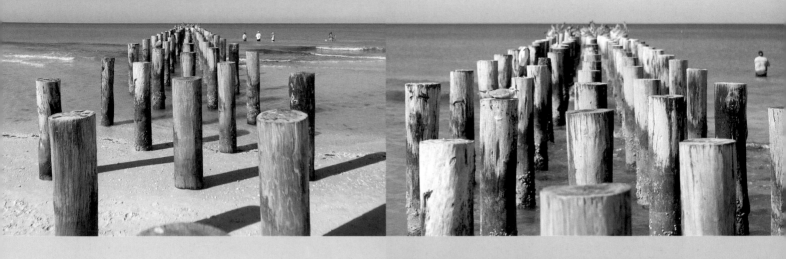

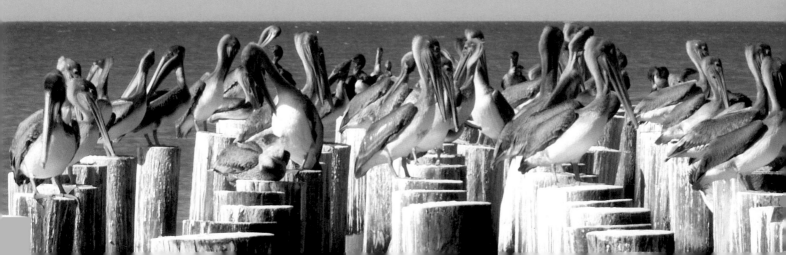

Depth of Field

Although it is true that you cannot control the focus of objects that are on the same plane or distance as your subject, you can control the degree of sharpness of objects that are at different distances from your main subject. The way to do this is by choosing an appropriate aperture that allows you to control the depth of field.

Imagine that you are taking a simple head-and-shoulders portrait outdoors. The light is right, and your subject is framed correctly. However, the background is either unattractive or may be a distraction in the finished photograph. If you use a 100mm lens set at an aperture of f22 and focus it on your subject's eyes, a great deal of detail behind the subject will remain in focus. However, if you open up the aperture to f2.8, nearly everything behind the subject is thrown out of focus and the background becomes a blur of indistinct colour. In portraiture this effect can look very attractive, and means that in the final composition all the emphasis is on the person's face, which of

course is the purpose of a portrait picture and the nuances in their expression will be what gives the shot its individuality.

You might want to relate the background to the main subject – this could be the case if you want to show a working or living environment, or when you are photographing people in the foreground of a landscape picture. If you choose the widest aperture, for example f2.8 as described above, the background is out of focus. If, on the other hand, you use a small aperture, more of the picture is in focus, so you can have the subject and the background equally sharp.

Because the aperture determines how much light passes through the lens onto the film or sensor, you need to adjust the shutter speed accordingly. For example, if you use a wide aperture, such as f2.8, you can use a faster shutter speed than if you use a smaller aperture, such as f22. It may be necessary to use a tripod or other support when using a shutter speed of under 1/30th second.

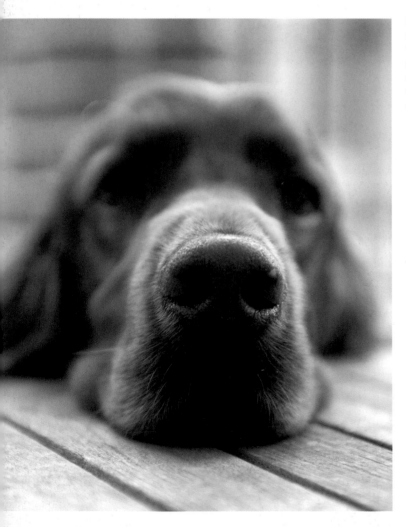

Left: Depth of field is at a minimum when you are working with a wide aperture. This is even more apparent when taking close-up pictures. Here, the lens was focused on the dog's nose, and very little else is sharp.

Opposite: The correlation between aperture and depth of field is shown in these pictures. In (1) a 28mm wide-angle lens was used with the aperture set at f2.8. Even at this aperture, on a wide-angle lens, much of the picture is sharp with only minimal fall-off to the background and foreground. In (2) the lens was stopped down to f8. Here, even more of the picture is in focus, with only the foreground planter still unsharp. At f22 (3) everything is now in focus including the nearest planter. In (4) a normal lens was used and the aperture was set at f2.8. Less of the picture is sharp than with the wide-angle lens at the same aperture. Stopped down to f8 (5) and f22 (6), still less of the picture is sharp, especially in the foreground. When a 200mm telephoto lens is used, the area of sharp focus is greatly reduced, especially when set to an aperture of f2.8 (7). At f8 (8) the picture is still visibly unsharp in the background and foreground. Even stopped down to f22 (9), these areas are slightly unsharp.

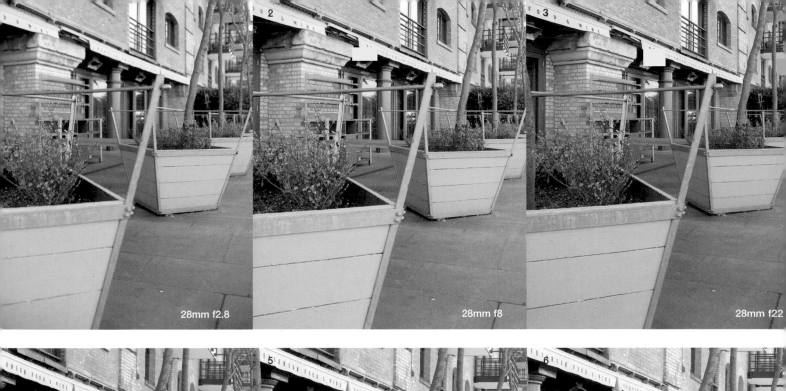

28mm f2.8

28mm f8

28mm f22

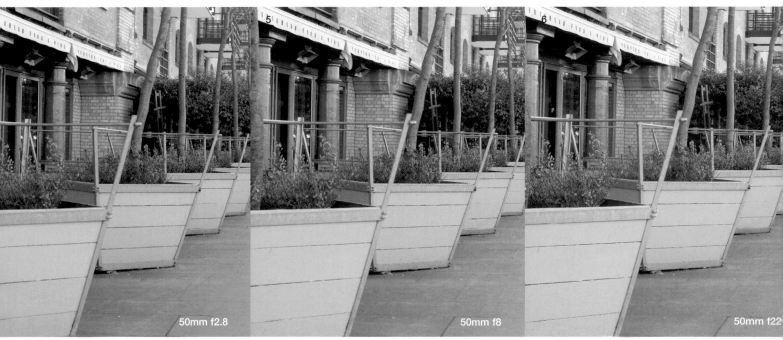

50mm f2.8

50mm f8

50mm f22

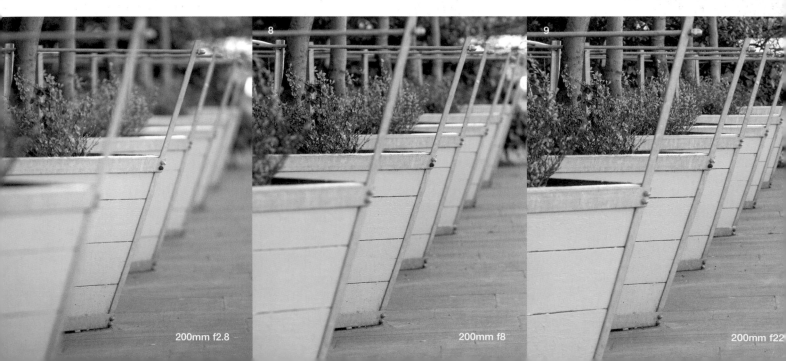

200mm f2.8

200mm f8

200mm f22

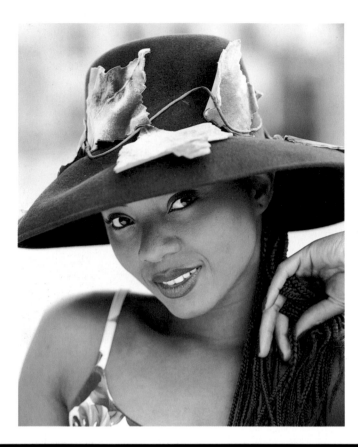

Left: In portrait photography, you can use a telephoto lens to control the sharpness of the background. In this shot, a wide-aperture f2.8 was set on a 200mm telephoto lens. This put the background out of focus to create a neutral effect with the emphasis on the model.

Opposite: In contrast, I needed to get as much in focus as possible for this artist in her gallery. I chose a 28mm wide-angle lens and used an aperture of f16. This has kept the artist and virtually all of the gallery in sharp focus.

Area of Sharp Focus

Aperture of f2.8 Aperture of f8 Aperture of f22

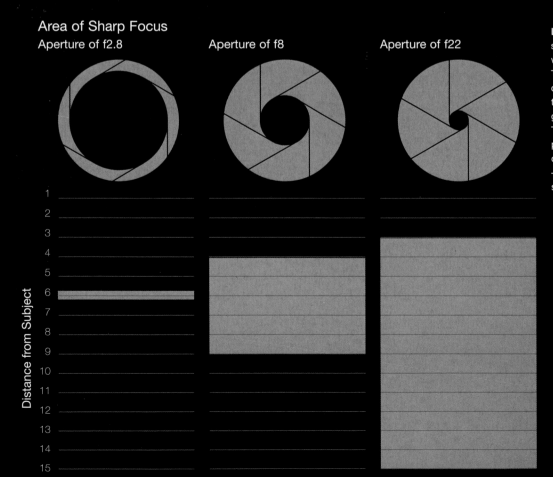

Distance from Subject

1
2
3
4
5
6
7
8
9
10
11
12
13
14
15

Left and right: This illustration shows the scale of sharp focus when the lens is stopped down. The wider the aperture, the less of the picture is sharp, whereas the smaller the aperture, the greater the area of sharp focus. This is replicated in the three pictures opposite, where the area of sharp focus can clearly be seen – from left to right, the lens was set at f2.8, f8 and f22.

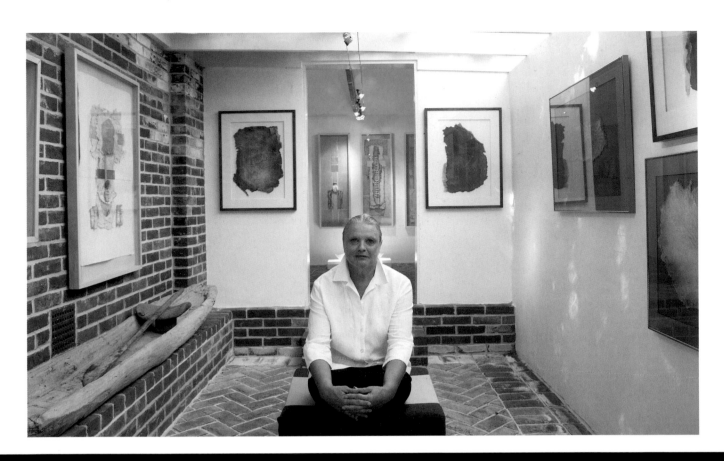

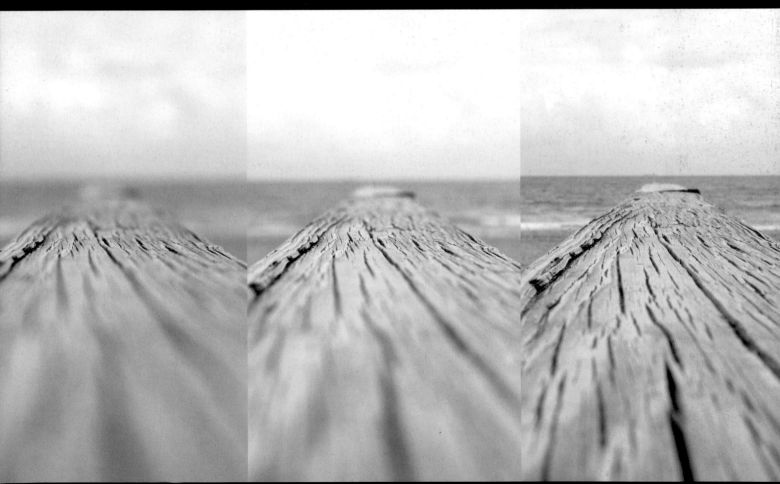

Exposure

Most cameras on the market today come with some type of built-in metering system, the exceptions being the bottom of the market, or basic point-and-shoot compact cameras. The systems are more sophisticated the further up the range you go, and some manufacturers go so far as to claim that, using their particular foolproof system, you can get a perfectly exposed shot every time. This isn't true, however, as even the most sophisticated metering system can be fooled, with the result that any shot can end up looking quite different to the way you saw the scene.

This is where digital cameras have the advantage over film models, in that once you have taken a shot you can look at the image on the LCD screen and examine a histogram. This spreads the exposure levels over a scale in the form of a graph. Levels bunched towards the right of the scale indicate overexposure, while levels bunched towards the left of the scale show underexposure; an even spread of levels throughout the scale means the shot is correctly exposed. With digital, once an image has been downloaded into a computer, a certain amount of correction can be made, which can be useful if you have had no time to get the correct exposure for the shot.

If you are using film, especially colour reversal film which produces colour transparencies, getting the right exposure can be much more critical. If your shots are badly overexposed, the detail will be lost forever; if they are underexposed no amount of burning-in will bring detail back into the areas of shadow. Many professional photographers bracket the exposure when shooting with this type of film. This means taking several shots of the same scene at different exposures and choosing the best one once the film has been processed. Some photographers take a Polaroid before shooting on film to check for such things as correct exposure; however, most do not have this luxury, so getting it "right" is crucial to a successful shot. As with so many aspects of photography, it is getting to know how your equipment works and its limitations that will assist you in getting your shots correctly exposed every time.

Overexposure
1 The exposure data of a digital image is displayed as a histogram on the camera's LCD. The levels in this image are bunched towards the upper end of the histogram, or to the right in the LCD. This indicates that the brighter parts of the image are burning out and overexposing.

Normal Exposure
2 The levels are spread through the histogram evenly, showing an even spread of tones. The levels bunched in the middle shows a good exposure for an average image.

Underexposure
3 In this example the levels are bunched to the left and blocking in, showing underexposure.

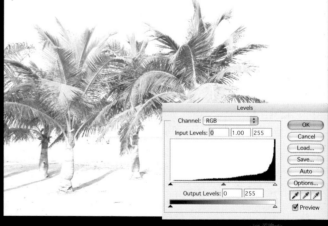

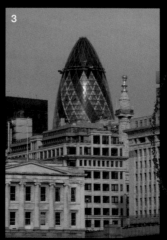

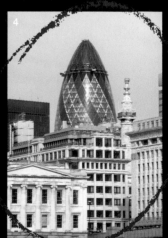

Right: Although many cameras with autoexposure perform well in normal conditions, there are times when they can give misleading results. Because the sky is the dominant feature in this picture and is much brighter than anything else, the camera's meter has taken its reading from this area. This has resulted in the building in the foreground coming out totally underexposed.

Far Right: In this shot I set the camera's metering mode to manual and took a reading for both the building in the background and the one in the foreground. I then averaged the two, which gives a more pleasing result.

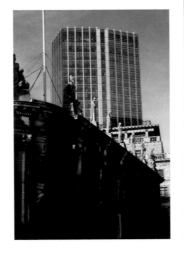

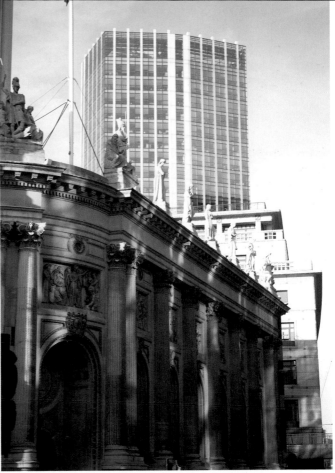

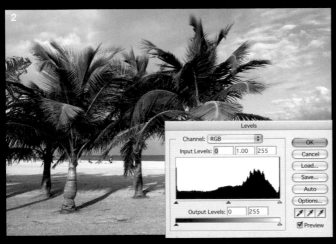

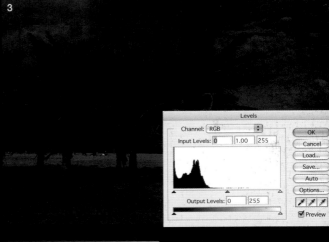

Left: In this series of pictures you can see the effect of bracketing the exposures.
1 The shot is too dark and underexposed. By gradually increasing the exposure, the shot becomes lighter.
4 Correct exposure.
7 Increasing the exposure further results in overexposure.

ISO

The rating given to the speed of every film available, ISO stands for International Standards Organization and indicates the sensitivity to light of each film. ISO has superseded all the previously used film rating standards, such as ASA and DIN.

The standard ratings are 100 ISO or 200 ISO, out of a range that extends from 12 ISO to beyond 1600 ISO. Films with a low ISO are known as slow films, and those with a higher ISO number are called fast films. The rating on 35mm film is DX-coded: once the film has been loaded, the camera electronically "reads" a bar code printed on the cassette and adjusts the metering system accordingly.

High-ISO film has more sensitivity to light than low-ISO film, and is thus better suited to low-light conditions or for freezing action with fast shutter speeds. Grain can become more noticeable with fast film, but you can use grain creatively. For example, you can achieve an effect similar to pointillism, the 19th-century painting style where small dots of pure colour are applied – viewed from a distance, they combine to produce an appearance of great luminosity. The most famous exponent of this style was the French painter, Georges Seurat. In fact, going to art galleries can be a very useful exercise in learning about composition, because many of the techniques employed by famous painters are as applicable to the photographer as they are to the painter.

When it comes to digital photography, the more sophisticated cameras have a facility for adjusting the ISO: the higher the ISO you set your camera to, the grainier the image will appear – just as with film. In digital photography this "grain" is called "noise", and it can be added to a fine-grain shot when using a program such as Photoshop on the computer.

You can also add noise to a fine-grain film negative or transparency that has been scanned into the computer, and this can greatly add to the overall character of your finished photograph. However, noise can cause problems in shadow areas at print stage.

Fine Grain

When the ISO is 100, photographs have fine grain or noise, as can be seen in the shot to the right. Even when the shot is enlarged and the grain increases and the sharpness begins to suffer, the result is still within the parameters of acceptability.

Coarse Grain

With ISO at 1250, the grain or noise increases dramatically and the overall sharpness of the shot begins to diminish, as seen to the right. In certain situations this would be unacceptable but, as in the shot opposite, grain can add a dimension to the image that makes it more attractive.

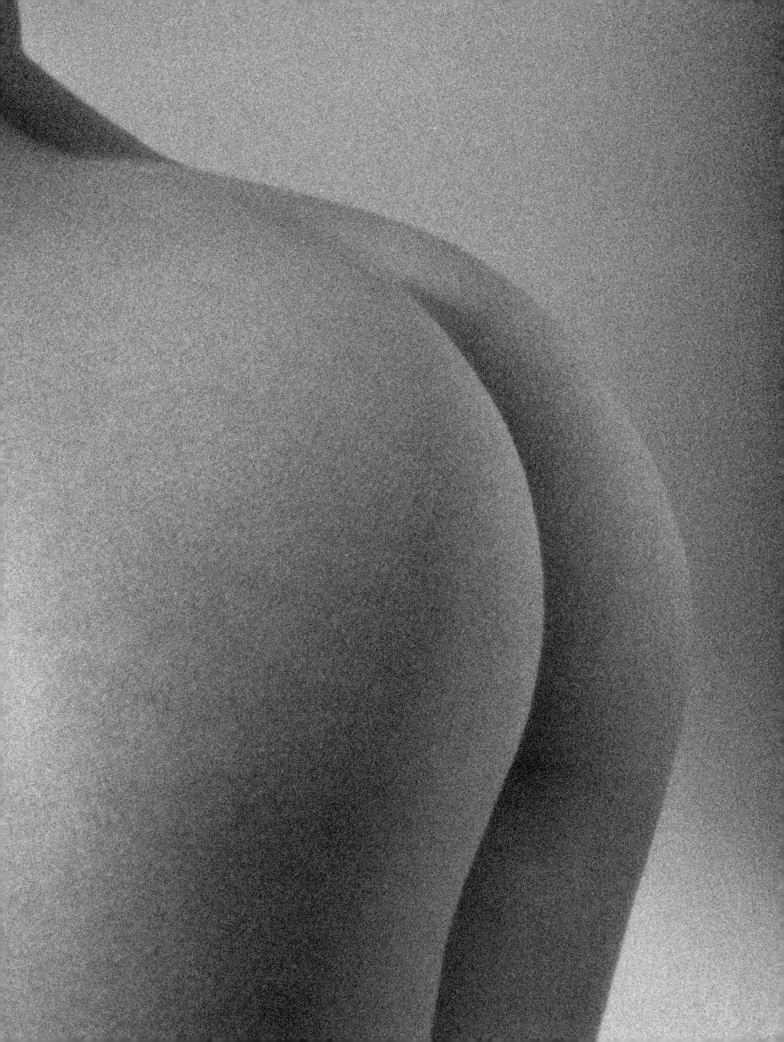

Light and Colour

Because they take it for granted, many people never really consider the light when about to take photographs – they make the assumption that there is enough light for the film or censor to record an image, or they use flash or some other form of artificial light if there appears not to be enough. However, it is rare that the light is so low that photography is impossible. What should be considered more than the quantity of the light available is its quality.

Although daylight is seen as white light, it is really made up of all the different colours of the rainbow or spectrum, ranging from red, through orange, yellow, green, blue and indigo, to violet. These colours do not stop suddenly when they meet each other, and can be divided into three main colour bands: red, green and blue, which, if they were projected in equal intensity onto the same spot, would appear colourless.

The quality of light changes throughout the day. The rising and setting sun on a clear day can have quite a red colour; in photographic terms, this is called "warm". When the sun is at its highest at midday, the light is "bluer" or "cooler". The colour of light is measured on a scale known as Kelvin, which measures absolute temperature. The colour temperature of white light sources ranges from approximately 3,000° Kelvin (K), the light of a domestic tungsten light bulb, through to about 8,000° K in the shade under overcast or hazy skies.

In addition to there being a difference in colour at different times of the day, there is also a difference in shadows: at the beginning and end of the day, shadows are long, while at midday, when the sun is at its highest, they are short. If the contrast between the light and the shade or shadows is too harsh, some areas of the photograph will be very dark, while some areas will be too light and the detail will be burned out. Our eyes can usually accommodate this variation in contrast, but the camera, or, more correctly, the film or sensor, cannot.

Understanding how the colour of light is recorded and recognising how long or short a shadow is, are probably the most important steps in beginning to "see" a good photograph.

Below: The weather plays an important part in how the light affects photography. In dull weather there is very little shadow detail, and if not thought out carefully, your shots can take on a flat appearance. Look for drama in the light, such as a heavy sky (left). When the sun is out there is a lot of shadow detail, and the light gives the colours of the lifeguard's station a much more vibrant feel (right).

Opposite above: In this shot, the light is coming from the south so the north-facing bar front never gets direct sunshine. This creates shadowless lighting. (The opposite would be true if the shot had been taken in the southern hemisphere). However, the strong colours still make an effective image.

Opposite below: In the evening at sunset the light gets far warmer, and the sky takes on a fiery glow. When shooting digitally, be careful that the auto white balance setting does not take the atmosphere out of the shot by reducing warmer tones in the sky.

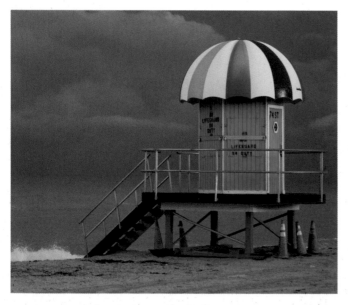
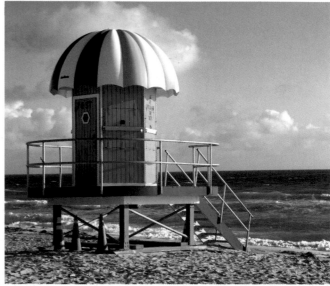

Above: At midday the sun is at its highest, and if it is a bright day colours will reproduce vividly. It is for this time of day that most colour films are balanced.

Opposite: About half an hour after sunset, the sky takes on a deep blue hue – this lasts for only about ten minutes before the sky turns black with very little atmosphere. It pays to be alert to these changes so that you can be in position to get the shot before the light is lost.

Black and White

If colour photography records a scene, black-and-white photography interprets it. Over the last few years there has been a resurgence in the use of black-and-white photography, and the reason for this is more than a transitory fashion or fad.

As photography has grown in popularity, people have become more discerning in the way they "see" and read a picture. It is all too easy for any colour photograph, however good or bad, to appeal because, after all, that is the way we see our environment. Because black and white is an interpretation of a scene, rather than a straight record of what is there before the eye, it is down to the photographer's skill to create an image that uses texture, tone and composition – of course these are important elements in a colour photograph, but in black and white they are essential.

When you compose a black-and-white photograph, it is the direction of the light that emphasizes the textures of your subject: texture could be the lines on a person's face, the surface of the sand in a desert, or the bark on a tree. The deeper these furrows are, the greater the contrast between the shadows and the highlights. By moving your viewpoint, this contrast increases or decreases, depending on the angle of the light to the viewpoint; often just a slight shift in viewpoint or camera angle can have a dramatic effect on the feel of a particular scene or subject.

If the contrast between the shadows and highlights is too great, the picture can lack a good range of mid-tones; this in itself is not necessarily a bad thing, and can be used to your advantage. However, a good range of tones is more likely to produce a succesful photograph than one where all the tones are taken from the extremes of the spectrum.

A good exercise is to view your shot on the computer after you have downloaded it or scanned it in, and then view it in a program such as Photoshop. By experimenting with the contrast and brightness levels, you can alter the tones to the extreme. This helps you become more observant when taking your pictures and assist you in seeing in black and white.

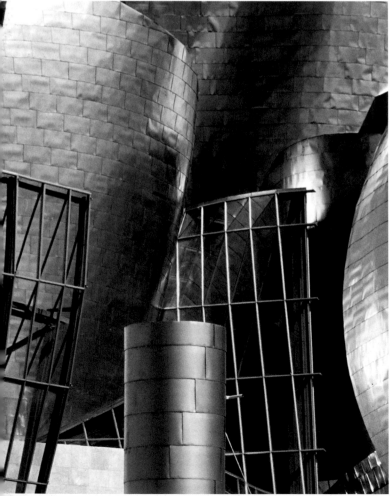

Left: The Guggenheim Museum in Bilbao, Spain, with its titanium cladding and strong geometrical lines, lends itself well to being photographed in black and white. Good-quality printing is essential if you are to reproduce a full range of tones.

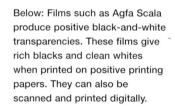

Opposite: The strong textures of the weathered wood and the rope make an ideal subject for black-and-white photography. The directional sunlight helped to emphasize these textures, and it was also important to have the shot razor-sharp.

Below: Films such as Agfa Scala produce positive black-and-white transparencies. These films give rich blacks and clean whites when printed on positive printing papers. They can also be scanned and printed digitally.

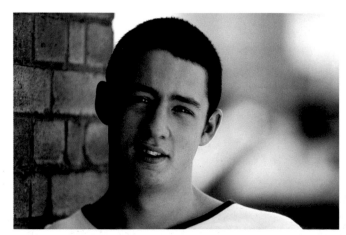

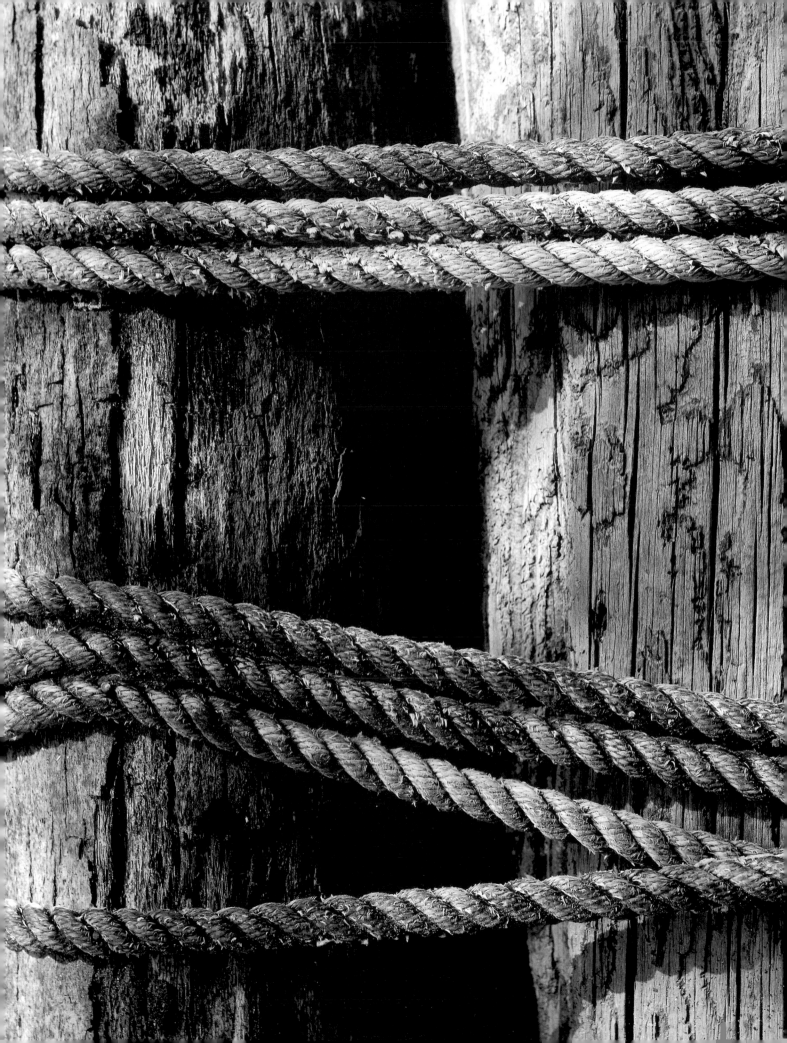

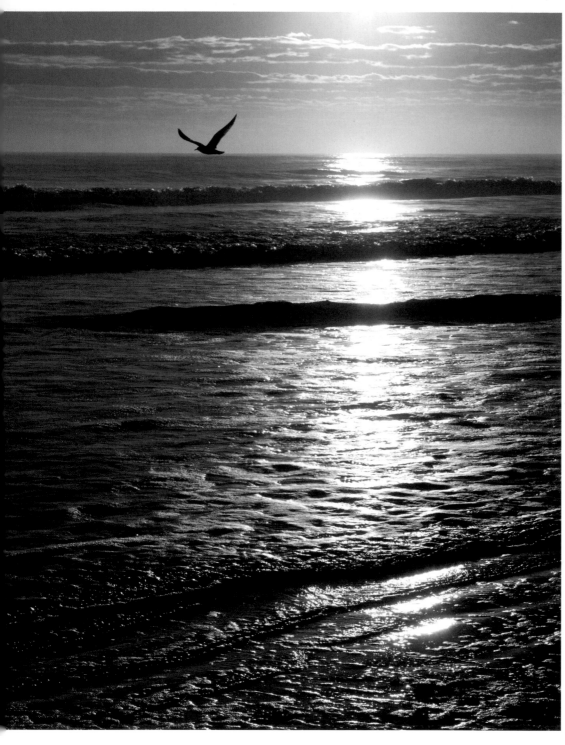

Above: Shooting directly into the sun and exposing for the highlights produced this low-key picture. The ripples in the water are particularly effective in black and white, as is the silhouette of the bird against the sky. When shooting into the sun, it is essential to use a lens hood to cut down the risk of flare.

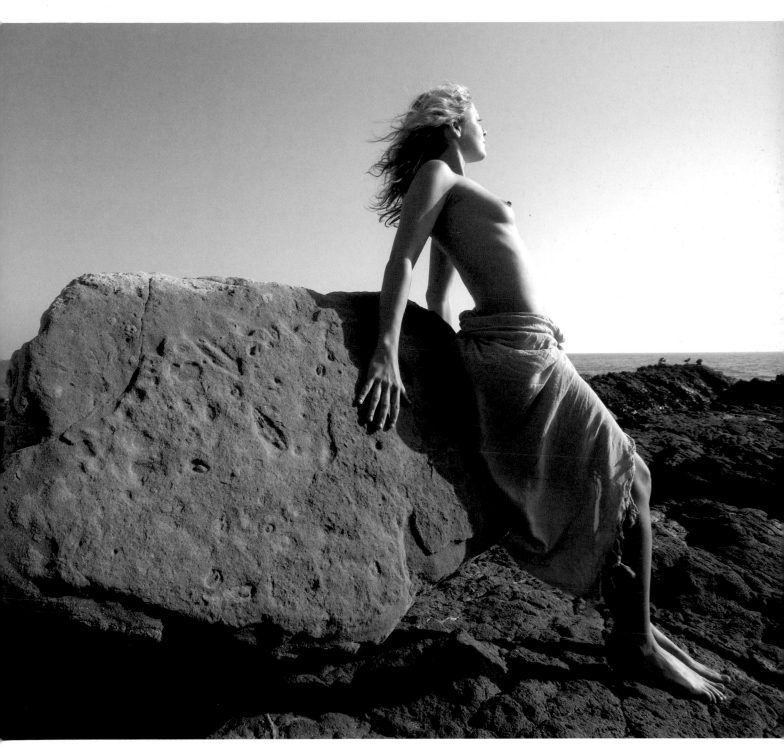

Above: Here, a strong directional light has picked out the detail in the weathered rocks. The wind blowing through the model's hair gives a strong feeling of the elements and creates a wonderfully natural shot.

The Golden Section

Perhaps one of the biggest flaws in many people's photographs is the lack of thought paid to composition. When taking pictures it is all too easy to shoot as quickly as possible without considering the three key elements of a successfully composed picture: the foreground interest, the middle distance and the background, together with the quality of the prevailing light and its direction. Stand back from the scene you want to photograph for just a few moments and study these elements to see how you can make a good picture better. It could be that just a slight movement in one direction or another has a significant effect on the overall composition.

From the days when the Ancient Egyptians built the pyramids and the Greeks refined their techniques to produce beautifully proportioned classical buildings, there has been a rule that artists and architects have followed when composing pictures or designing buildings – the Golden Section, or rule of thirds. What this means in pictorial terms is that the subject of the picture or photograph should be placed at the intersection of imaginary lines drawn vertically and horizontally a third of the way along the sides of the picture. Pythagoras, the Ancient Greek mathematician, proved that the golden section was the basis for the proportions of the human figure, and showed that the human body is built with each part in a "golden proportion" to all other parts. This theory was adopted and perfected by Leonardo da Vinci in the Renaissance.

It is worth remembering that in Western cultures the eye reads a picture from left to right, whereas in Arabic, Chinese or Jewish cultures, for example, the opposite is the rule. If this is a difficult theory to comprehend, consider how some cultures read a book from back to front and right to left, while others read a book from left to right and front to back. However, the Golden Section is still applicable in both cases.

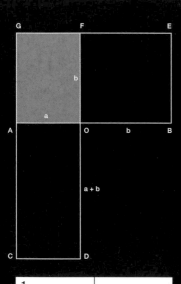

The Principles

The Golden Section refers to a proportion where the ratio between a smaller segment (a) and a larger segment (b) of a line is equal to the ratio between the larger segment (shaded rectangle) and the whole. A rectangle whose sides are in this ratio, about 1:1,618, is called a "golden rectangle".

1 Leonardo da Vinci made a close study of the human form and showed, following Pythagoras, how all the different parts of the human body were related by the golden section. This illustration shows how his theory works.

2 When you compose your pictures try to imagine a grid, as shown here. By placing the subject at the intersection of imaginary lines drawn vertically and horizontally a third of the way in from the sides, a well-balanced composition can be created.

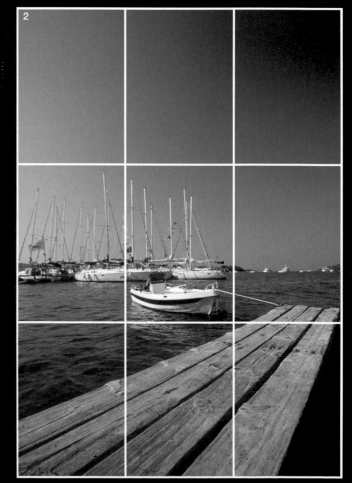

Right: The way you hold your camera has an effect on the overall composition of your photographs. In the two examples on this page, taken within a few moments of one another, you can see the effect of framing the picture in portrait and landscape modes. In this shot the camera was held in the vertical, portrait mode. This has resulted in a large area of unwanted foreground detail, and the Millennium Dome is lost in the background. The capstan and rope hover insignificantly in the foreground, and the whole picture has very little shape or interest to it.

Below: By framing the picture in a horizontal, landscape format, the capstan and rope are brought to our attention immediately, and the Millennium Dome is much clearer and echoes the shape of the capstan. The river plays much more prominence in the shot, and the overall composition shows the classic proportions of the Golden Section.

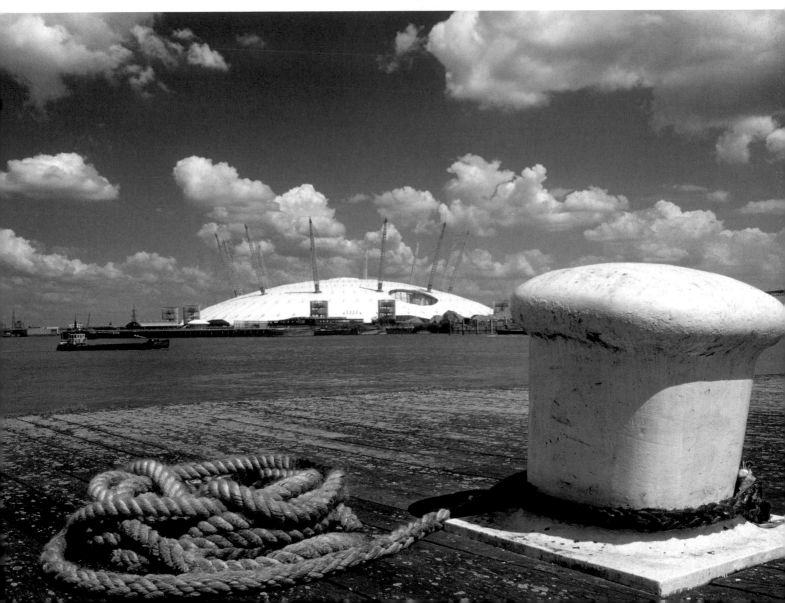

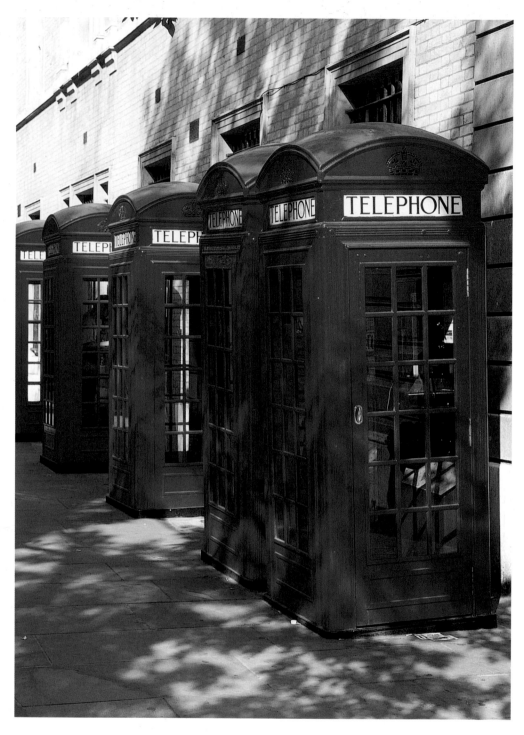

Above: A telephoto lens was used in this shot to compress the row of red telephone boxes and create a tighter composition. The strong diagonal lines fit all the criteria of the Golden Section.

Opposite: Taken from a central viewpoint, using the cables of the Brooklyn Bridge to create a strong composition, perfect framing was essential for this shot to work. The grid screen in the viewfinder helped to get the vertical and the horizontal elements exactly level.

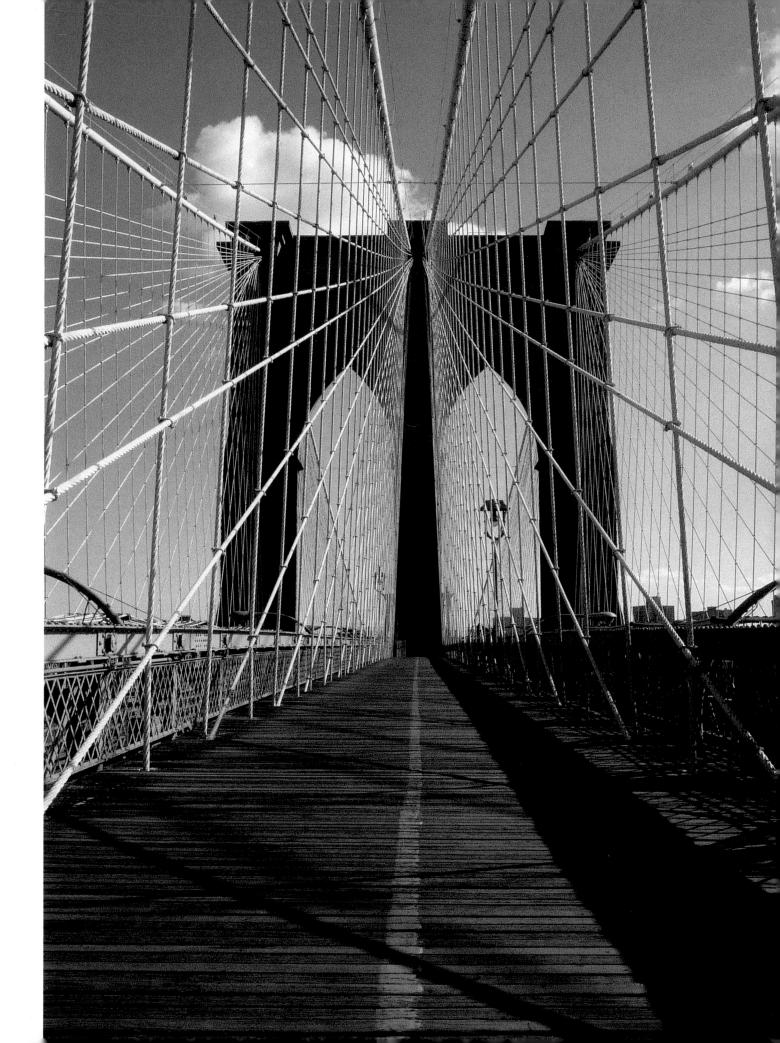

Symmetry

For every rule in photography that implies a "correct" way of composing a picture, there are ways of achieving effective results when the rules are broken. Although the Golden Section (see page 38) implies that good composition can only be achieved when your subject stands at the intersection of imaginary lines drawn vertically and horizontally a third of the way along the sides of the picture, it is possible to achieve striking shots when your subject is in the middle of the frame.

Many people think that beauty in the human face is the result of perfect symmetry. There can be no doubt that well-balanced proportions do create a harmony of form. If you think about it, there are very few people who have this quality, so when it does occur, it strikes us as exceptional. Even when looking at a face with this quality straight on, where one side is perfectly balanced with the other, you can still see how the rule of the Golden Section applies. Often it is the pose you get your subject to take and the background you choose to photograph them against that can create symmetry, as you can see in the shot below. The way the model cups her face in her hands and leans forward on her elbows emphasizes this approach.

In addition to the human face, many other subjects lend themselves to being centralized in the frame when photographed. So often in these cases it is the viewpoint that determines whether the shot will be successful: for instance, when photographing a building, especially a skyscraper, a low viewpoint can greatly exaggerate the perspective and the symmetry – and the same is true when photographing a straight road or track.

Whether you place your subject centrally or to one side of the frame, the shot is only going to work if it is correctly balanced. There is no reason why a symmetrically composed picture cannot be effective, as you can see in the examples on these pages. The important point to remember is to learn to look at any potential shot with an imaginary grid over it. If your camera allows you to change the focusing screen, one with grid lines is a great help in seeing and composing your photographs.

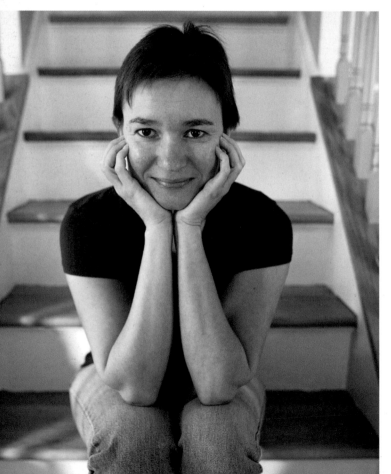

Left: Just because your subject has been placed in the middle of the frame does not mean that you cannot get effective, well-composed shots. This portrait works particularly well because of the symmetrical balance of the background and the pose. If she had been positioned to one side of the staircase, the shot would not have worked so well.

Opposite: What makes this picture work so well is the mirror-like reflection of the boat in the water. If the wind had been just a little stronger, the reflection would have been lost in the ripples of the water.

Overleaf: This picture of the ceiling of the Assumption Cathedral in the Kremlin in Moscow was taken with a fish-eye lens. Because the angle of view is so great, I had to lie on my back so that I did not appear in the shot myself. Choosing this viewpoint has resulted in a shot with near-perfect symmetry.

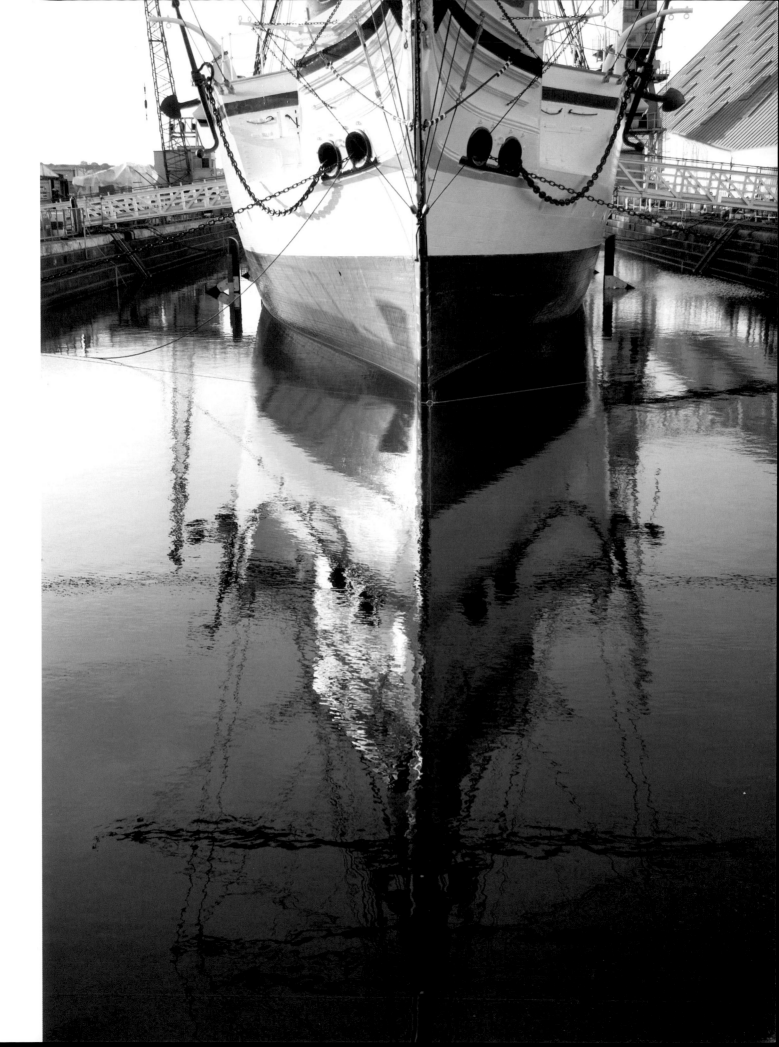

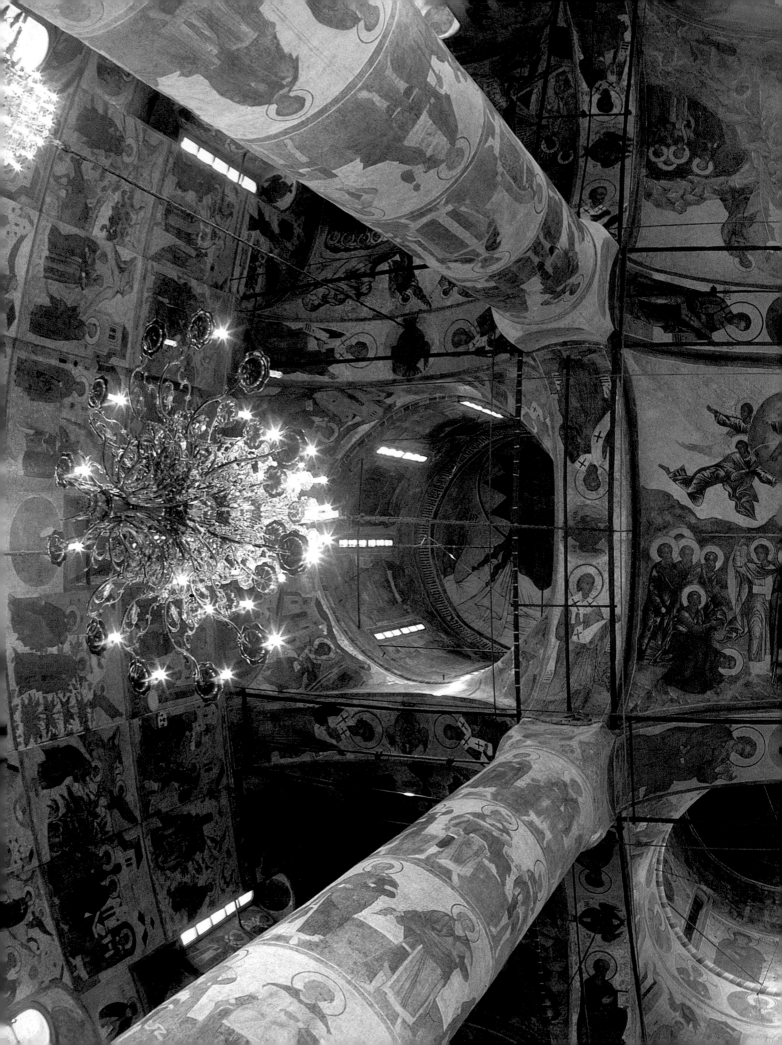

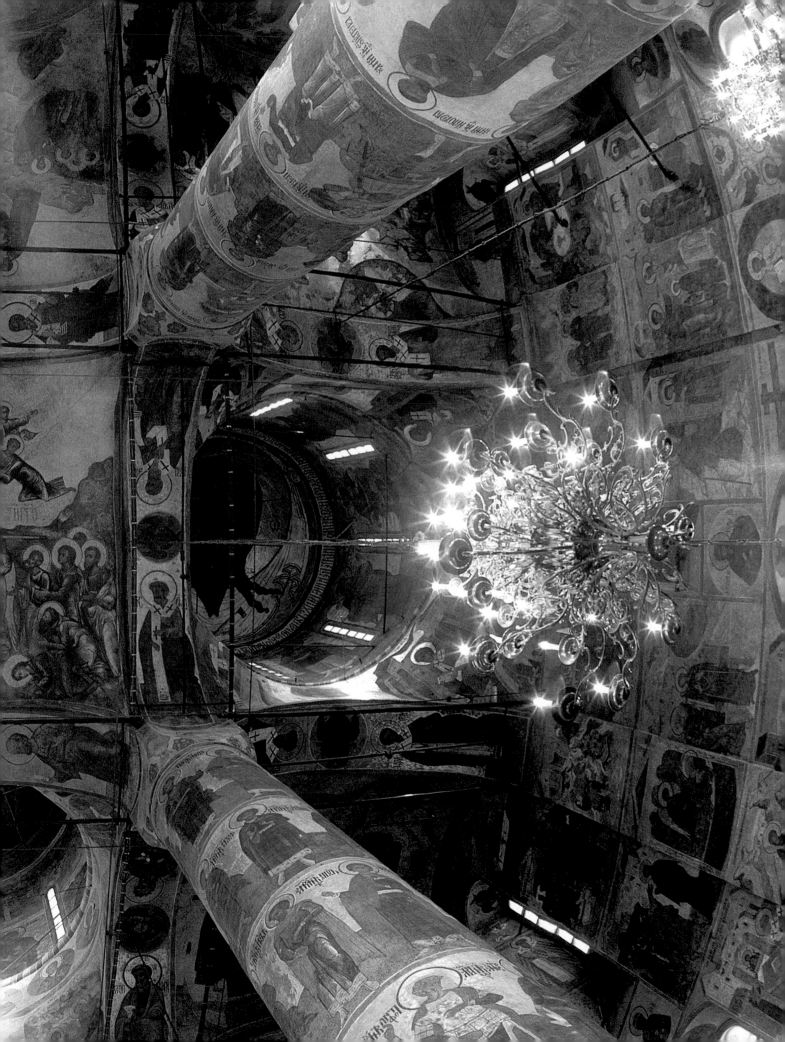

Normal Lenses

Because most cameras now come with a zoom lens fitted as standard, there seems little need for what is known as the standard or normal lens. This lens derives its name from the angle of view that it gives, which is roughly the same angle of view as the human eye.

Perhaps the reason why this type of lens is overlooked so much is because people seem to be obsessed with zoom lenses. However, because of its similarities in angle of view to our own vision, a normal lens can be the perfect choice when framing your picture. It gives good depth of field and allows you to go in close without fear of distorting the subject. It is also a good lens for practising the art of composition because, unlike a variable focal length or zoom lens, you are bound by the constraints of the fixed focal length. This puts the onus on you to choose your viewpoint with greater care, and to give more consideration to framing than might otherwise be the case.

When used on a 35mm camera, the focal length of a normal lens is 50mm and it records its image on film that measures 24 x 36mm. On a medium-format camera, such as a Hasselblad, where the image area is 6 x 6cm, the standard lens has a focal length of 80mm; on a Mamiya RZ, where the image area is 6 x 7cm, the focal length is 110mm.

As 35mm is the most popular format camera, most manufacturers still refer to it as the standard, and this has carried over to digital cameras. The problem with this comparison is that the sensor that records the image on a digital camera is usually smaller than that of the film format (24 x 36mm); it is only at the very expensive end of the digital range of 35mm SLR cameras that the size of the sensor is the same. This means that on the majority of digital cameras a 50mm lens is slightly telephoto and therefore gets less of the scene or subject into the frame.

It is not uncommon for most normal lenses to have a wider maximum aperture than other lenses. With 35mm cameras this might be f1.8, but lenses as fast as f1.4 or f1.2 are not unusual. These can be a great asset in low light.

Left: Because the normal or standard lens gives an angle of view that roughly corresponds to the human eye, it does not exaggerate the perspective, which is what would happen in a shot such as this if it had been taken with a wide-angle lens, or flatten, as would happen with a telephoto lens.

Opposite: This shot was taken with the aperture set on f2.8, so the depth of field is quite shallow. However, the girl's body is clearly visible, and there is great emphasis on her eyes.

Wide-angle Lenses

It is more than likely that your camera is fitted with a zoom lens with a range from reasonably wide-angle through to medium telephoto. In the 35mm format this range can be from 35mm to 90mm. When the focal length is set to 35mm, the angle of view is much wider than what we perceive to be the normal angle of view, as seen with the naked eye.

Wide-angle lenses range from extreme angles of view, such as the fish-eye, which, as its name implies, has an angle of view of 180°, through to 35mm. The fish-eye lens is very expensive, and its uses are limited; however, in certain situations it can be very effective, especially when photographing interiors such as churches, where the emphasis might be on an elaborate ceiling or a row of columns.

More useful is the extreme wide-angle lens, such as the 17mm. Depending on the quality of the optics, this type of lens gives very little distortion. The depth of field is enormous, even at wide apertures, and the amount that can be included in the frame is vast. The next most popular focal lengths are 24mm and 28mm. Again, these have a much wider angle of view than the naked eye, and the depth of field is still very good.

Because of this greater depth of field, more care needs to be taken when composing your shots. For instance, it might not be beneficial to the overall composition to have as much in focus as you might otherwise include. If this is the case, your choice of viewpoint and angle of view should be paramount considerations. On the other hand, the possibilities of unusual perspectives are greatly enhanced when you can have an object as close to the lens as 18in (46cm) and still keep everything in focus to infinity. Very few digital cameras offer extreme wide-angle capabilities. It is only with full-frame digital SLR cameras, such as the Canon EOS 1DS, with its huge range of lenses, that offer true ultra-wide-angle capabilities, but these models are relatively expensive.

Left: When photographing tall buildings with the camera pointing upwards you will get the effect known as converging verticals (see page 68–69). This is greatly exaggerated when using wide-angle lenses. Although this effect is not strictly a true perspective, it can greatly enhance the dynamics of the shot and shows every rule can be broken.

Opposite: Wide-angle lenses can add a dynamic quality to your pictures with their greater depth of field. Here, the volley-ball net dominates the left-hand side of the frame and sweeps into the shot at a dramatic angle. The use of a fast shutter speed has frozen the players and the ball in mid-air.

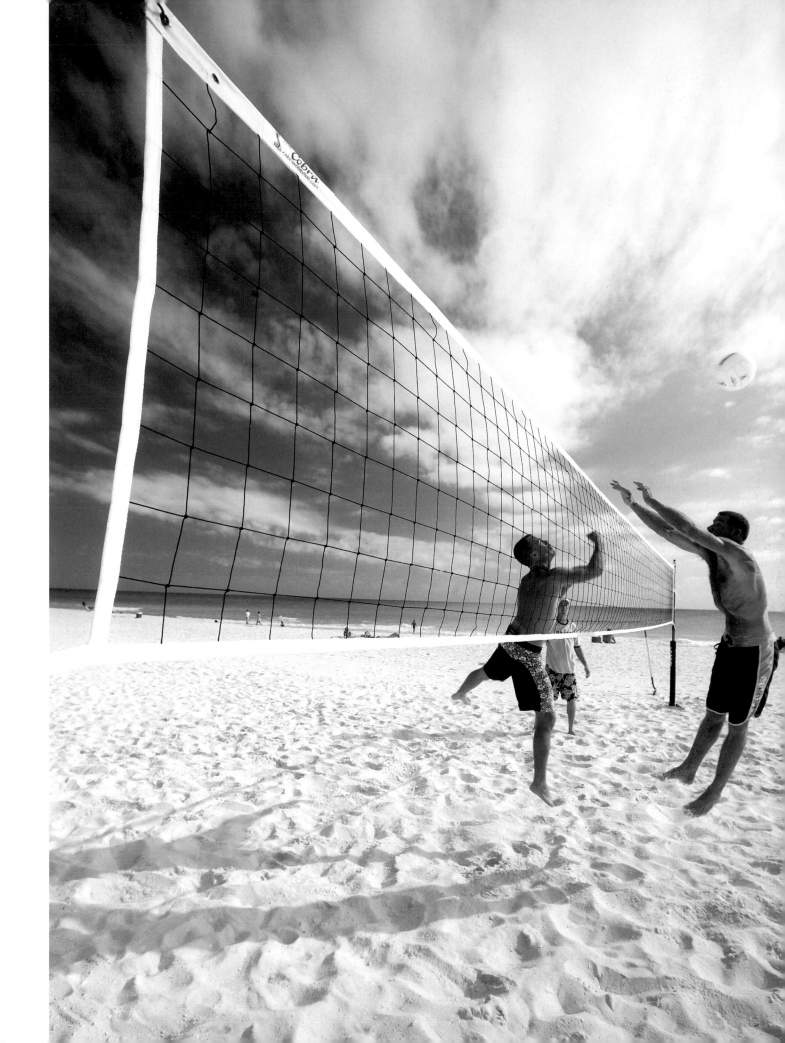

Telephoto Lenses

Telephoto lenses are sometimes referred to as zoom lenses, but while this may be true in certain cases, it is not necessarily the rule – for example, you can have a wide-angle zoom lens. Perhaps the reason for this anomaly is the fact that zoom lenses usually protrude from the camera's body to a greater degree than a standard or wide-angle lens.

Telephoto lenses fall into four groups. In 35mm terms, lenses up to a focal length of 90mm are classified as short telephoto. Lenses with a focal length between 100mm and 250mm are called medium telephoto, and lenses over this and up to 600mm are referred to as ultra-telephoto lenses; anything over this is extreme telephoto.

Apart from their ability to bring distant objects closer, do telephoto lenses have any other uses? With their shorter depth of field, even at small apertures, they are ideal for isolating your subject, especially in portrait photography. The fact that you can get the background completely out of focus, thereby creating an anonymous, mottled-looking backdrop, is a great aid to composition. Telephoto lenses also allow you to literally maintain a physical space between you and your subject, which can be very advantageous, especially if your subject is nervous when having their portrait taken.

The lenses' other ability is to "compress" a picture. This means that objects placed one behind the other appear to lose a sense of space between them, so you can fill the frame with a perspective that is quite different to that achieved by standard or wide-angle lenses.

Telephoto lenses are also good when it comes to framing, as unwanted detail can be cropped out without the need to move in closer, which might be physically impossible. This is a great aid to composition, as so many potentially good shots are ruined by the intrusion of irrelevant detail.

If you are using an ultra-telephoto lens, the chances are that you will need to support it on a tripod or monopod, as it will be virtually impossible to hold completely steady, although many lenses now feature an image-stabilization system.

Left: Telephoto lenses can be particularly effective when taking portrait photographs. Because of the shallow depth of field at wide apertures, the background falls out of focus rapidly. This creates a muted backdrop and makes your subject stand out.

Opposite: With telephoto lenses you can crop out unwanted detail that might affect the overall composition if it was included. In this shot I used a 150mm lens, which framed the shot perfectly, and the feeling portrayed is one of light and tranquillity.

Format and Framing

The most obvious way of filling the frame is to move in close – why then, do most people seem to keep moving backwards when taking their shots? There may be a disparity between what the viewfinder sees and what actually comes out, but…

If it is not possible to get closer to the subject, try changing lenses or zooming in so that the frame is filled. If you are taking a landscape picture and there is a large area of uninteresting sky, you could use the branches of a tree, for example, to mask this portion of the shot. On the other hand, if you can find something in the foreground that will fill the frame, you might be able to angle the camera downwards to crop out the sky. If that doesn't work, you can change position to include some compositional detail on one side of the frame or the other. Is it possible for your subject, if it is a person, to lean against a tree or wall? In addition to filling an area of the frame, this will also add a more natural feel to the shot. Another way to fill the frame is to decide whether your shot would look better framed landscape or portrait. A lot of people appear to believe that photographs can only be taken when the camera is held in the horizontal, or landscape, position – but most people's faces fit into the frame of a camera when it is being held in the vertical, or portrait, position. But it is not just people – even with landscapes or photographs of buildings it is worth experimenting with the different ways that you can frame your shot by simply turning the camera one way or another.

Of course, if you are shooting with a digital camera, it is relatively easy to crop your shots once they have been downloaded into your computer, and you can have conventional film cropped when you have your prints made, but both of these methods are time-consuming and, in the case of the latter, expensive. The other thing to bear in mind is that the more you enlarge either digital or conventional film, the more clarity you lose, and the more perceptible the size of the pixels or the film's grain becomes.

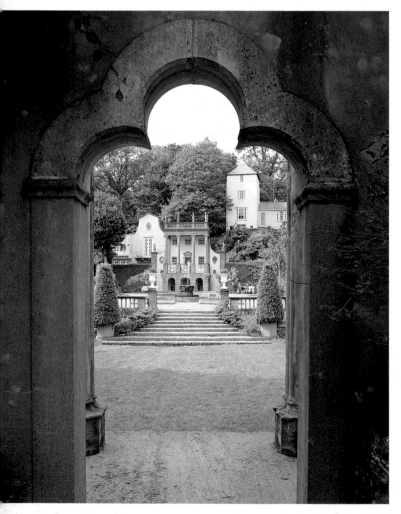

Left: Sometimes when composing your pictures it is beneficial to employ a framing device such as the arch in this shot. Apart from the fact that it makes an interesting frame it leads the eye into the picture to the buildings in the background. Such devices can also be used to hide unwanted detail.

Below and opposite: Often the composition of a photograph can be altered by choosing between a landscape or portrait format. The shot below was taken with the camera in the horizontal or landscape position. Although it works well enough, I felt that by turning the camera to the vertical or portrait position (opposite), the overall composition was better. The boats in the foreground fill the bottom of the frame with greater impact, and the additional sky gives the shot greater depth.

Viewpoint

On seeing a striking view, many people just point their cameras at it and then move on; very few really look at what is before them and try to find the best viewpoint. Instead of moving around the subject to explore all the possibilities with different angles or lower or higher viewpoints, they stand where they first became aware that a shot might be worth taking, and hope for the best. They might even take it out of a car window without stopping! The reason for this approach is often that because people feel they cannot move the subject, there is nothing they can do about the final composition of the photograph.

With a building, tree or landscape, for instance, which are all in fixed positions, it is true that the subject cannot be moved in the same way that a person or small object can. But with careful consideration and patience, and taking time to explore all possible viewpoints and angles, it is rare that a better shot cannot be achieved. Think about the following points every time you look through the viewfinder.

Does the subject fill the frame? If not, is the composition diminished by unwanted detail? Would it be better if you were to move closer or find a position that enables you to use other detail to lead the eye towards the main area of interest, so that it does not become overwhelmed by the background? Does your subject have to be in the middle of the frame? It might be better to place your subject to one side of the composition. Without even moving your feet you can do this by simply turning the camera one way or another, or choose a lower viewpoint by getting down on one knee.

Don't forget that the time of day at which you take your shots can play an important part in selecting a viewpoint. As the position of the sun changes the shadows that it creates get longer or shorter: it may be the case that if you return to your chosen viewpoint at a different time, the position of the light might enhance the composition. By planning ahead, you can make sure that you are in position at the best viewpoint to take advantage of the lighting.

Left and below: Moving slightly to the right has improved this picture of a monastery. The row of columns on the right is now tighter, because the trough on the extreme right has been cropped out. The foreground is cleaner, and cropping in tighter on the left has made the view towards the arched door much stronger.

Right: It is surprising how just a small change of viewpoint can greatly alter the feel of a shot and create an unusual composition. In the shot of the jetty (above), the angle of view is at eye level and the jetty leads us into the shot. However, when the camera angle is altered to ground level (below), the shot takes on a different dimension. The boards filling the foreground create strong lines of perspective that are missing in the first picture, and give a greater sense of depth.

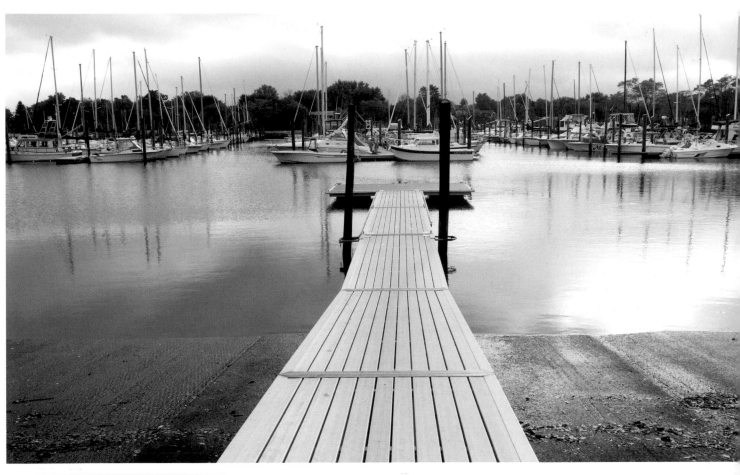

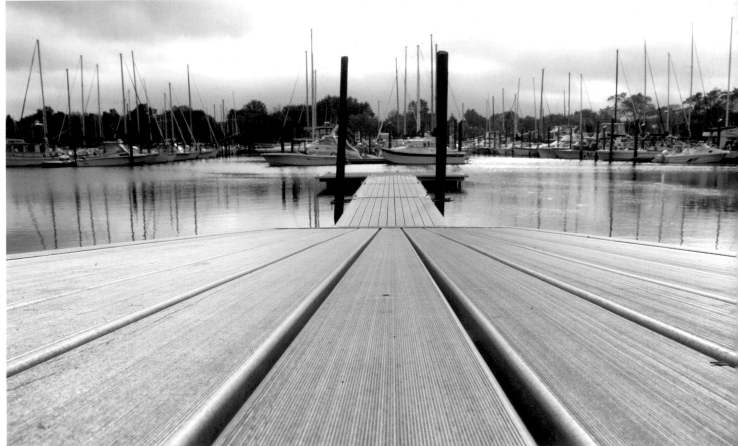

Above: This picture was taken from a high viewpoint with a medium telephoto lens. This tightened up the shot and created a real sense of depth, as well as height.

Opposite: In contrast, I used a 17mm ultra-wide-lens to photograph these autumn leaves, getting down on the ground to get as low a viewpoint as possible. The vibrant colours of the foreground leaves have great impact, which would have been lost with a higher viewpoint.

Foreground

There are many ingredients in shooting a well-composed, photograph, each of which has equal importance. However, one area that is essential to get right is creating foreground interest. A point of interest close to the chosen viewpoint can lead the eye into the picture, or can be used as a framing device. Many photographers fail to see what is right in front of them, and it is only when looking at the final print, when it is too late to make any changes, that they realize that they could have used a tree, rock, arch or road as a device for creating foreground interest.

You can use the foreground to your advantage to hide untidy objects or ugly intrusions in the middle or background of the picture. You can use a tree or an arch as a framing device in the foreground, and to hide unwanted detail, at the same time using this device to lead the eye into the shot and create a sense of depth.

Another tried and tested way of creating foreground interest is to use a road or the furrows in a ploughed field. By taking a low viewpoint, you can use these to fill the foreground and create a dramatic sense of perspective.

If you do use a framing device in the foreground, you need to take care with exposure – for example, is the foreground in shadow as compared to the middle or background of the shot? If this is the case, it might be better to take the shot at another time of day, when the overall picture is more evenly illuminated. If you decide to include a road or field in the foreground, is the required exposure greater than that required for the sky, so all cloud detail is lost? In this case, a graduated neutral density filter holds back the exposure required for the sky, allowing you to expose the foreground correctly.

If you are shooting digitally, you can shoot two exposures, one for the foreground and one for the sky, and then fit them together in the computer later as a composite image (see pages 130–33). This method really requires you to use a tripod, as both exposures need to be taken from exactly the same place for a realistic effect.

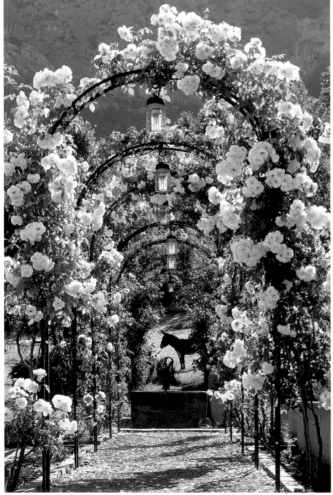

Left: The trellis in this shot is slightly compressed due to the use of a 200mm telephoto lens. The shot was taken at f22, which kept the important foreground detail sharp, as well as the donkey. The use of the lens has also brought the donkey closer, making it very much part of the composition, perfectly framed by the flowers in the foreground.

Below: In these two shots of the same building, the foreground of the left-hand picture is cluttered and untidy, and the building is lost in the distance. By using a telephoto lens (right) the foreground is much tidier and the building stands out more.

Opposite: I used the capstan in this view to create foreground interest. Its strong colour contrasts well with the yellow ropes and adds another angle to the composition. I took several frames, and chose this one, where the catamaran is to the right of the large ship.

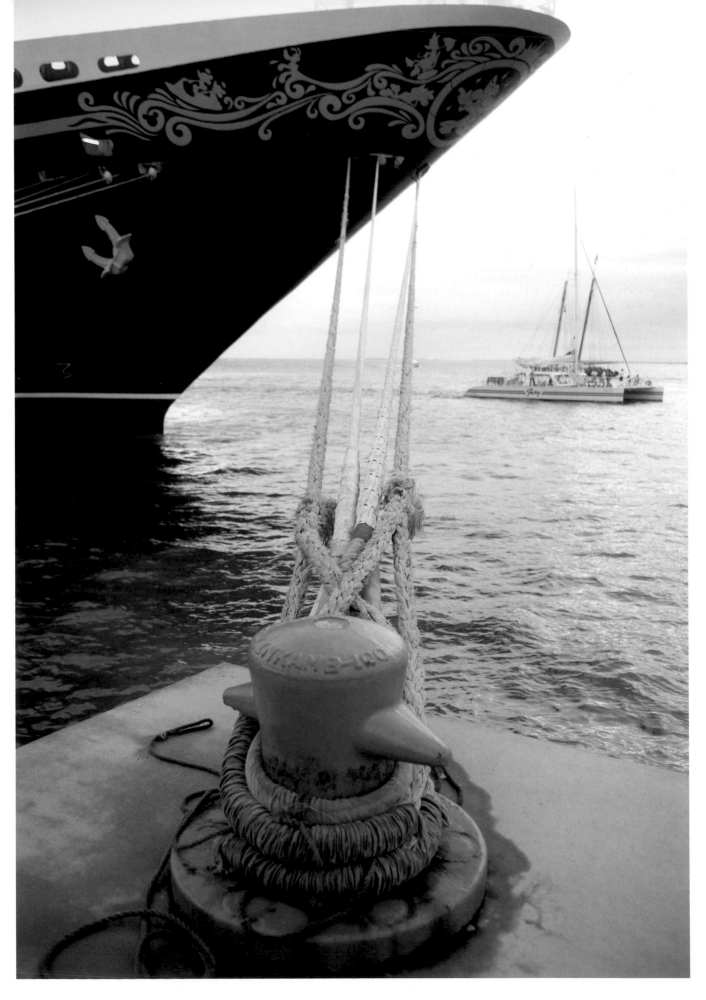

Background

Whatever you are shooting – a person, object or landscape – the background plays an essential part in a successful composition. When it comes to looking at final prints, your eye can be confused if the background is so busy that the main subject becomes indistinguishable from it.

In any photograph the background should act as the backdrop that sets off your subject in the same way as a stage set in a theatre: if the backdrop is so busy that the actors are dwarfed or camouflaged by it, the production becomes very tedious and the audience soon loses interest. Photography isn't any different, and people will start to dread looking at your holiday pictures, for example, if they can't actually see the main subjects in your shots.

A lot of photographers believe that they have no control over the background if the subject is a landscape. Of course you cannot move mountains or uproot trees, but you can move what might be only a few inches or centimetres either way to eliminate unwanted background detail.

You can change the focal length of your lens: a telephoto lens enables you to crop out unwanted areas of background and give the impression of compressing the background, by appearing to bring it closer. On the other hand, a wide-angle lens, with its greater depth of field, and a low viewpoint can keep both the foreground and the background sharp. A wide-angle lens also helps to lead the eye into the picture and, therefore, the background.

When you are shooting outdoors, backgrounds do not have to be physical objects – for instance, a stormy and brooding sky can make a dramatic background, not only to a landscape shot but also a portrait. If you are shooting digitally, it is possible to shoot a range of backgrounds and drop your subjects into them at a later date (see pages 130 and 138). If you are shooting a portrait outdoors, there are potential backgrounds everywhere. A good one could be something you see every day, like a weathered stretch of fence or wall, or even a doorway or the side of a building.

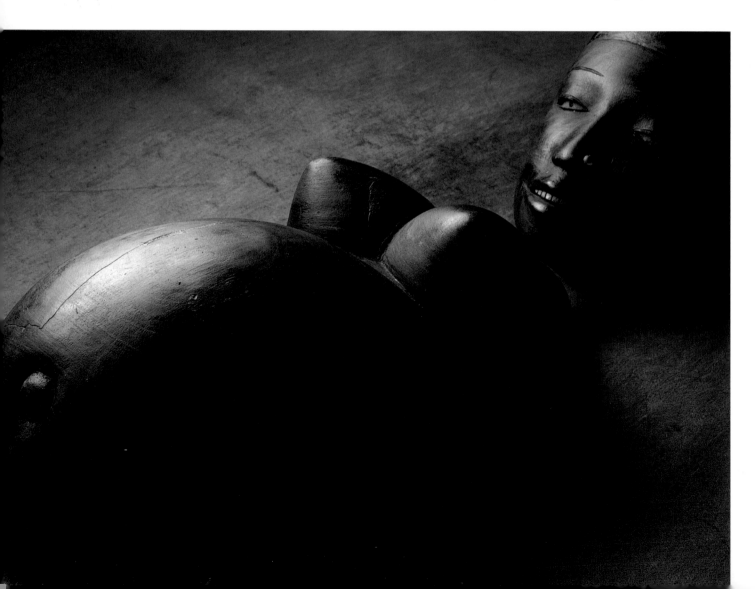

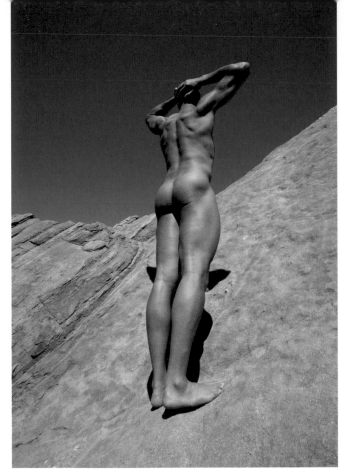

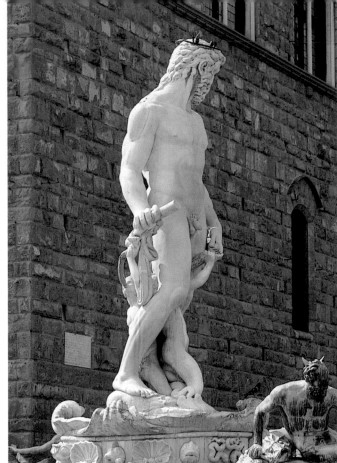

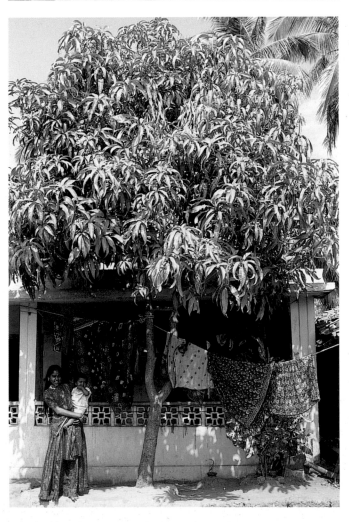

Opposite: I chose a piece of finely textured wood for the background to this shot of an African carving. It goes well with the smoothness of the figure, and backlighting helps create the right mood.

Above: The tone of the model's skin blends in well with the rocky background that he is standing on, while the contrast of the deep blue sky adds colour. Taking a low viewpoint makes the model look taller than he really is, and lends him a monumental feel.

Above right: Equally monumental is the Fontana di Neptuno in Florence. I walked around the statue, looking carefully at what would be in the background. In the end I decided that the wall worked best, with the figure standing out in isolation against it.

Right: The strong sunlight bathed this building in India, and I felt that the washing line of brightly coloured saris, together with the tree, made an interesting backdrop to this portrait.

Perspective

Whatever the finished form your photographs take – prints or transparencies – they are still two-dimensional views. To stop them looking flat and uninteresting, a three-dimensional sense of perspective needs to be added to the general composition.

Perspective helps to create a feeling of depth in a picture; without this feeling, the results can look very dull. Perspective can be created photographically by using naturally formed lines to create "linear" perspective, which, in its simplest form, can be a long, straight road that appears to taper to a point in the distance. Although you know the road is straight, the effect of tapering exaggerates the perspective and gives the feeling that the road goes on forever. If you focus on something close, such as the centre lines of the road, perspective can be enhanced by seeing these lines go from strips to one continuous band. The lower your viewpoint, the greater this effect. Another way to create this effect would be to use a line of trees at the side of the road.

When photographing buildings, it may be necessary to point the camera upwards; this creates what are known as converging verticals, when the building appears to taper towards its top. Converging verticals can give a false sense of perspective and make the building look a lot taller than in fact it is, but it can also dramatically change the perspective of the photograph. These can be corrected by using a PC lens, see pages 66–67, or later in Photoshop, see pages 68–69.

Choosing to hold the camera in the vertical or portrait position can also help to create a greater feeling of perspective than when holding it in the horizontal or landscape mode. By getting down low and including more foreground, especially with a wide-angle lens, a greater sense of depth can be created.

Always look at your chosen subject in as many different ways as possible, to discover what creates the greatest sense of depth or perspective, before you fire the shutter release.

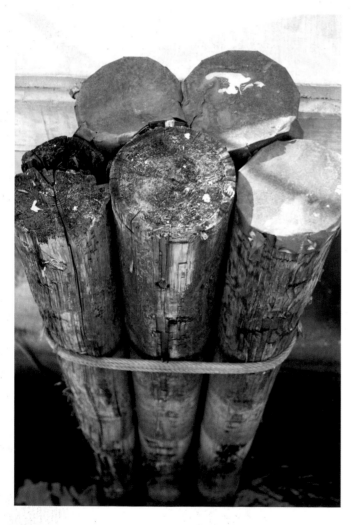

Left: I shot these buffers in a dock from above with a wide-angle lens, which exaggerated the perspective by making them converge into the water below. With a normal lens the perspective would not have been so great, nor the depth of field.

Opposite above: This is a classic road shot taken on the American prairies. The sides of the road seem to converge in the distance, and the clouds, enhanced by using a polarizing filter, add to the sense of depth.

Opposite below: I shot this skyscraper from low down, with the camera almost against the columns. The top of the building is barely visible as it soars towards the sky.

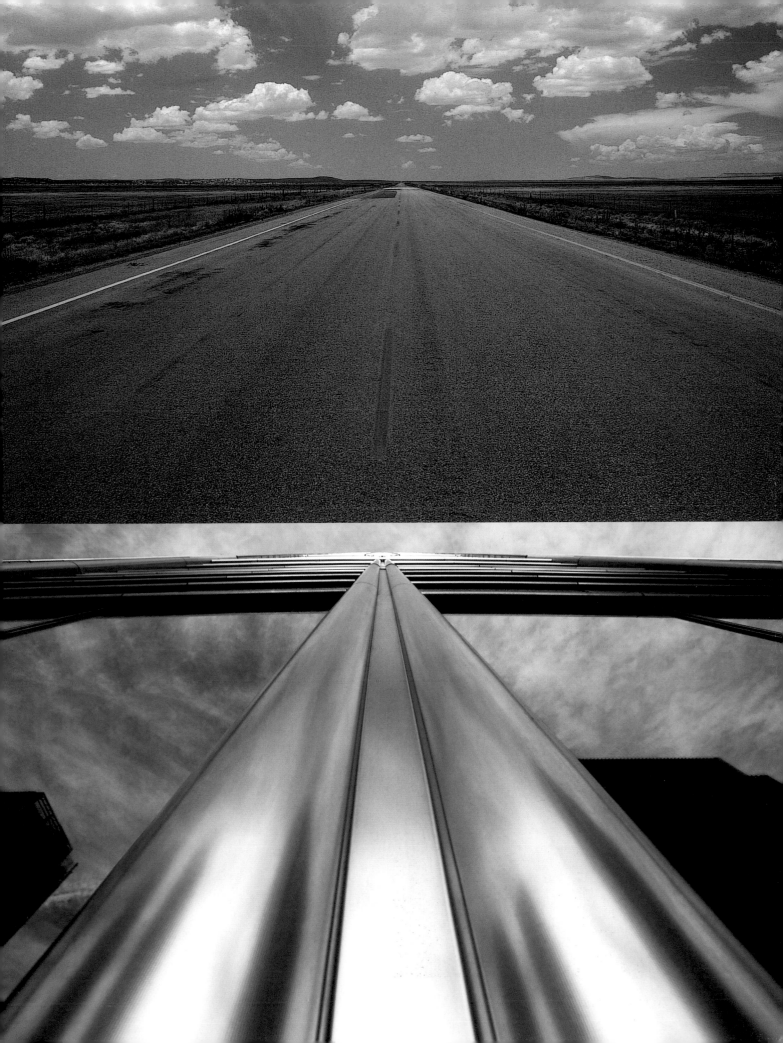

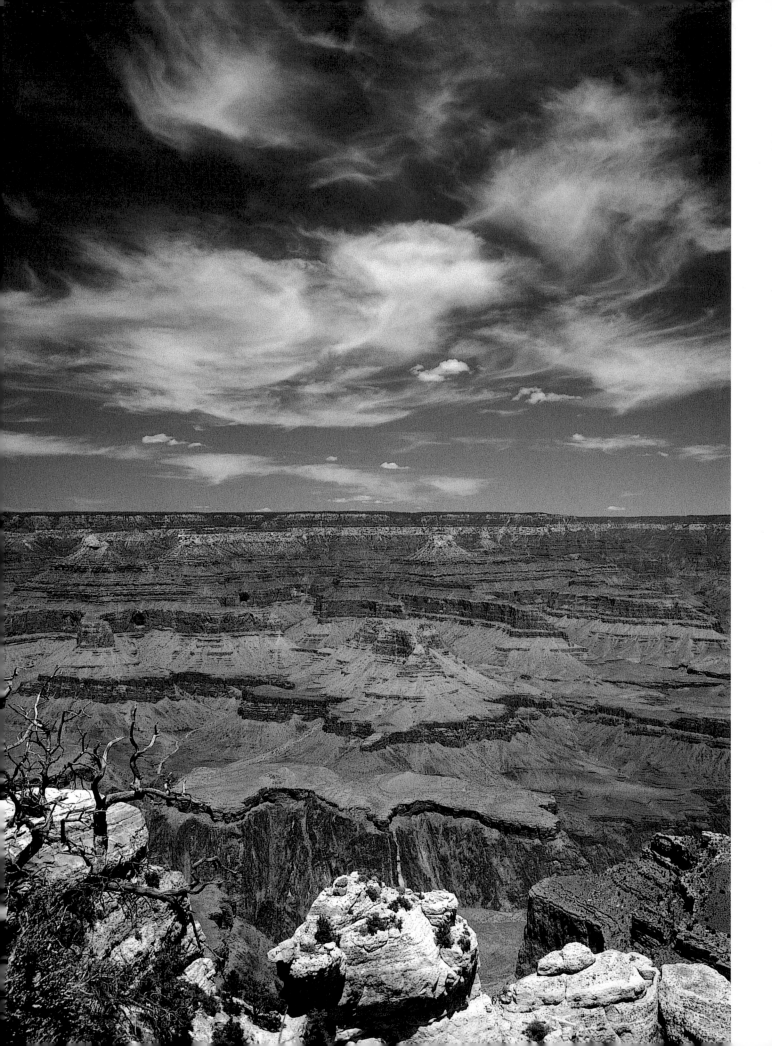

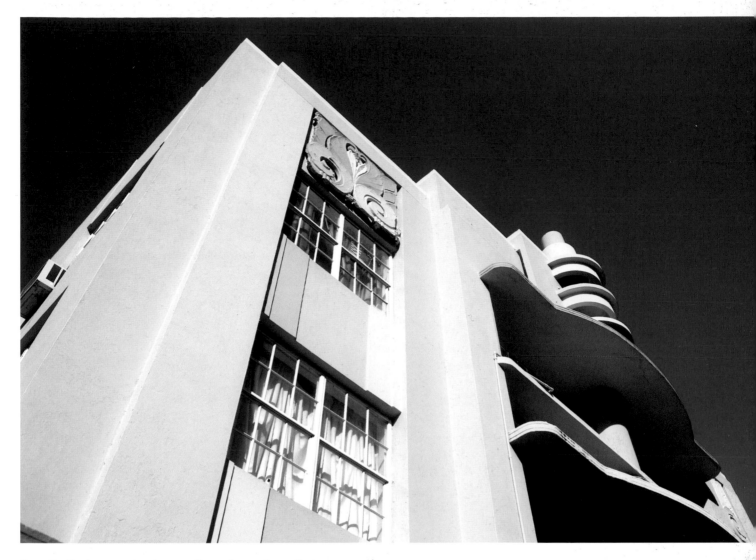

Opposite: The foreground rock adds a great deal to the sense of perspective in this photograph, by creating a sense of depth and space. Without this foreground interest, the shot would have looked flat and lacking in perspective. The wispy clouds lend to the feeling of depth.

Above: Converging verticals are the result of the low viewpoint used when taking this shot of an Art Deco building in Miami, Florida. The pastel colours of the architecture contrast well with the deep blue sky, and the perspective adds drama to the overall composition.

PC Lenses

Not many years ago, only large-format cameras had the ability to shift and tilt a lens, but now this function is available on a range of 35mm lenses. Shift lenses, better known as PC (perspective control) lenses, allow the photographer to shift the axis of the lens in relation to the film plane. Amazingly, this shift, often only a fraction of an inch or a few millimetres, allows you to get the whole of a building that might be several hundred feet or metres tall into your frame and make it appear that all the walls are completely upright and straight, with no tapering towards the top.

When you are photographing a tall building, often the only way to get it all in is to point the camera upwards. This results in converging verticals (see page 64), where the building appears to taper towards its top. The only way you can stop this happening is to point the camera at the building and make sure that the lens is parallel with the building. However, this usually results in the top of the building being cut off, and the shot may also include a lot of unwanted foreground detail. Using a shift lens, you can keep the whole building in the frame and straight, at the same time cropping out the unwanted foreground detail. The problem might be reversed in still-life photography. Let us imagine that you are photographing products that have completely straight sides. If you point the camera downwards, these sides will taper towards their base. Using the shift lens will eliminate this.

Shift lenses have another use. Imagine you are photographing a highly reflective building, car or mirror, and you want the subject in the middle of the picture. If you stand with your camera in front, you will be reflected in the surface. With a shift lens you can stand to one side of the subject and adjust the lens to bring the subject back into the centre of your shot, thereby keeping you out of the way of being reflected.

If your shift lens has a tilt function, you can use it to control the plane of sharp focus without having to stop down. This is a great advantage, especially when the light is low, when it might be impractical to use a small aperture.

Correcting the Perspective

1 When taking shots of tall buildings, it is sometimes necessary to point the camera upwards. This creates the phenomenon known as converging verticals, which give the appearance that the building is tapering towards the top.

2 To correct this, you need to make sure that the film plane of the camera is parallel to the subject plane. However, with an ordinary lens, even a wide-angle in certain situations, the top of the building will be cropped out, and the foreground will then dominate the shot.

3 When a PC lens is fitted to the camera it is possible to keep the film plane parallel to the subject plane, as you can then shift the axis of the lens and bring the whole of the subject into view.

3

1

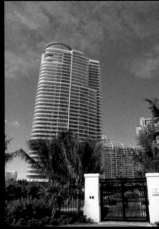

2

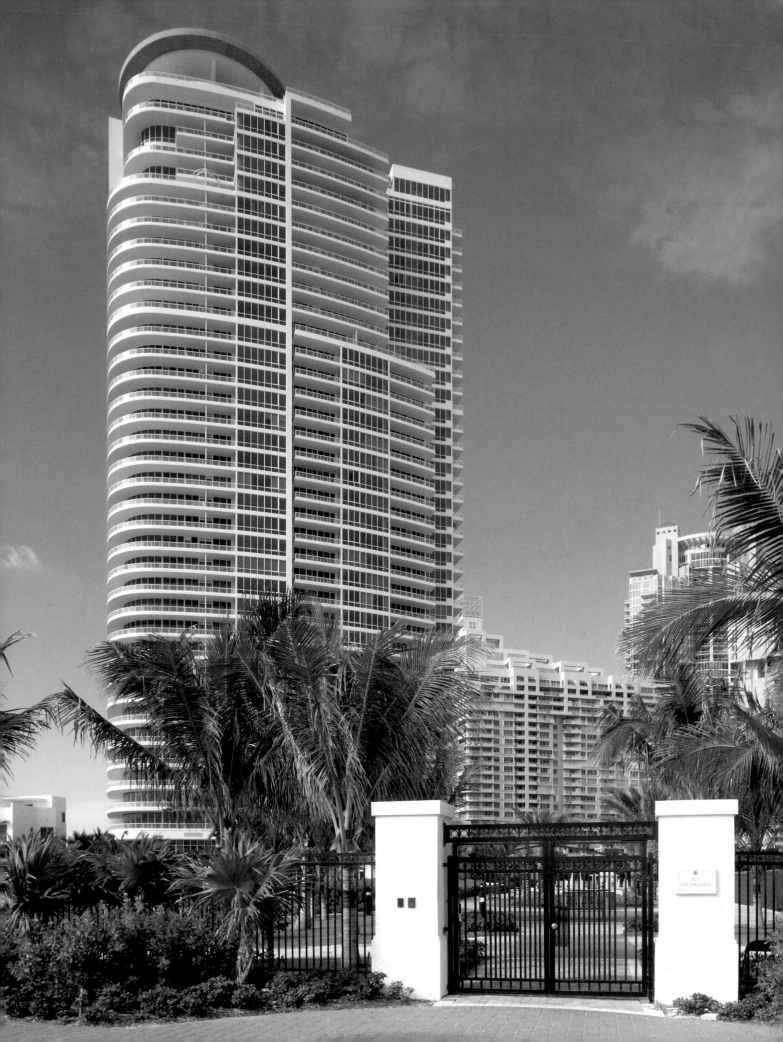

Digital Perspective

When you are photographing a tall subject it is often necessary to point the camera upwards to get the whole of the structure within the frame. If your subject is a building you may wish to avoid the resulting converging verticals as the sides of the building appear to taper towards the top. The distance the photographer stands from the building and the degree to which the camera is angled upwards are the determining factors that govern how severe the convergence of the verticals is. Basically, if the camera's film plane or sensor is not parallel to the subject plane, any verticals will be distorted.

It is possible to correct this phenomenon using a PC lens (see page 66), but this is an expensive piece of equipment and, unless you are going to do a lot of architectural photography, it is probably not worth the outlay. However, it is possible to correct converging verticals once an image has been downloaded into a computer. To do this you need to run Photoshop, Paintshop Pro or one of the other sophisticated imaging software packages currently available.

To correct the converging verticals use the Cropping tool which has an option to stretch your picture. By stretching it you can control the degree of slant or slope in the walls of the building. This, of course, has an effect on the final quality of the finished image. As each pixel is stretched, it loses vital tone and colour information and ends up with holes where no information is present (see 2a and 2b opposite). Fortunately the programme interpolates these holes and fills them in by adding more pixels. It is able to do this by reading the information in each of the surrounding pixels and then making its own judgement on what the correct colour balance and tone of the missing pixels should be. Because a certain amount of the sides of the original will be lost (see 3 opposite), always make sure you give yourself room when you take your shot, otherwise some of the building may fall outside the crop. When giving yourself space on either side of the shot, make sure that you don't step too far back, otherwise there is a danger that the resulting image will be too small and pixellate when enlarged later.

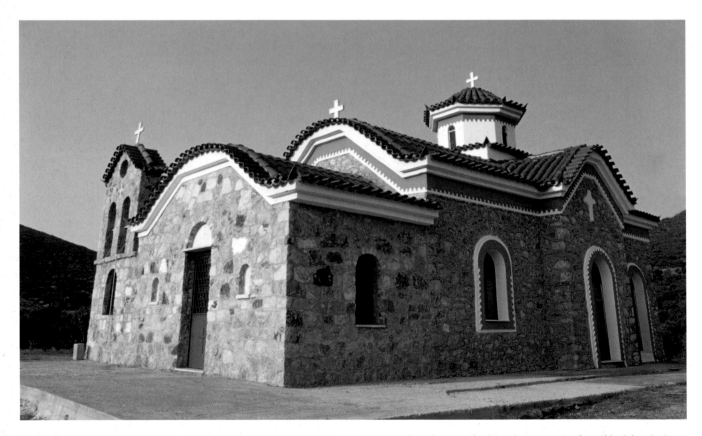

Above: It is frequently necessary to point the camera upwards to get the whole of the subject in the frame, as is the case here. The problem when doing this is that the sides of the building lean inwards towards the top, making the church look as though it is about to tip over, and it is not a true representation of the structure. If the building were a modern skyscraper, this convergence of verticals could be used to creative effect, but on a traditional structure such as this, it just looks wrong. However, rather than not shooting at all, or buying a PC lens, you can shoot from the best angle available and correct the perspective on the computer later. When you shoot pictures that you know will need to be corrected, give yourself as much room as possible around the main subject to allow for the loss at the sides.

Correcting Converging Verticals

The tool for correcting perspective is called the perspective crop tool. Each corner can be positioned independently so that the side crop lines are made parallel to the lines on the building that need to be corrected. The crop area – the undimmed part of the image – can then be pulled out to the corners. The same technique can also be used for converging horizontal lines.

2a/b The tool works by stretching the image where the subject is too narrow. On enlargement of the image, you may note that parts of the picture have become distorted. This is not normally noticeable when only slight correction is needed, but it can become more obvious if extreme stretching occurs, as the computer interpolates more information to fill in the gaps.

3 The image has been corrected and is much more aesthetically pleasing, with the sides of the building vertical and straight. Note how some of the original image has been lost in the cropping.

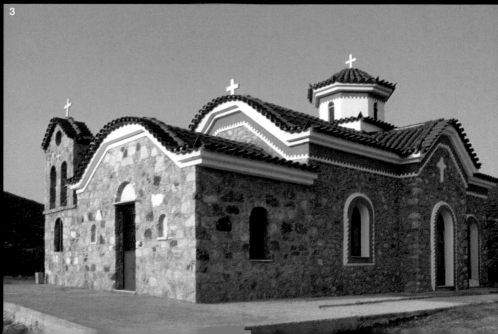

2 The Subjects

Portraits: General

Although there may be no hard and fast rules as to the best equipment for composing a portrait, a zoom lens with a range of 70–210mm is undoubtedly very useful. Not only does it enable you to get in close to your subject without crowding or intimidating them, but there is no danger of you casting your own shadow over them – this is particularly the case when taking outdoor portraits on a bright and sunny day, or when photographing children, for instance, where you might get too close to them.

The other advantage of such a lens is that if you use it nearer the end of its range – 200mm, for example – and use a wide aperture, the background goes out of focus, creating a far more muted backdrop. This also helps to eliminate unwanted detail and thus create a much more pleasing composition. The lens can help you to fill the frame and concentrate on a particular feature, such as eyes or mouth.

When shooting outdoors in bright sunlight, be careful that your subject does not squint, and keep a lookout for unwanted shadows around the eyes. If they do appear, try to move your subject to an area of overall shade, or get him or her to turn around to be backlit. Use a reflector or fill-in flash to correctly expose the face.

Always look for different angles, and remember that even a small adjustment in viewpoint can alter the composition of your portrait. For example, when you take a high viewpoint and look down, your subjects invariably look vulnerable, whereas a low viewpoint, means your subject looks down at you, giving an air of confidence and assurance.

In addition to composing a portrait so that the subject is looking straight at the camera, try to find a more relaxed pose, such as leaning on their hands or against a wall. If you are shooting a group, posing is crucial to the overall composition, and you need to take care with the area of sharp focus, especially when using long lenses and wide apertures.

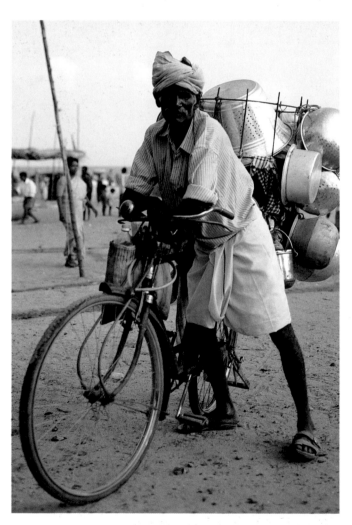

Left: It can sometimes be difficult to get a well-composed portrait of a complete stranger when travelling abroad, However, in this shot of an Indian pot seller, all the rules of composition have been applied and it adheres to the classic proportions of the Golden Section.

Opposite above: Using a wide-angle lens has created this striking composition of a sculptor. Although his hand is distorted and appears unnaturally large, it adds to the relationship between himself and the material he uses to create his sculptures, and brings his work to the forefront of our attention.

Opposite below: In contrast, this is a more formal setting but a relaxed portrait, and shows this woman surrounded by some of her art collection. The shot was taken with available daylight, with just a small amount of fill-in flash to keep the background even.

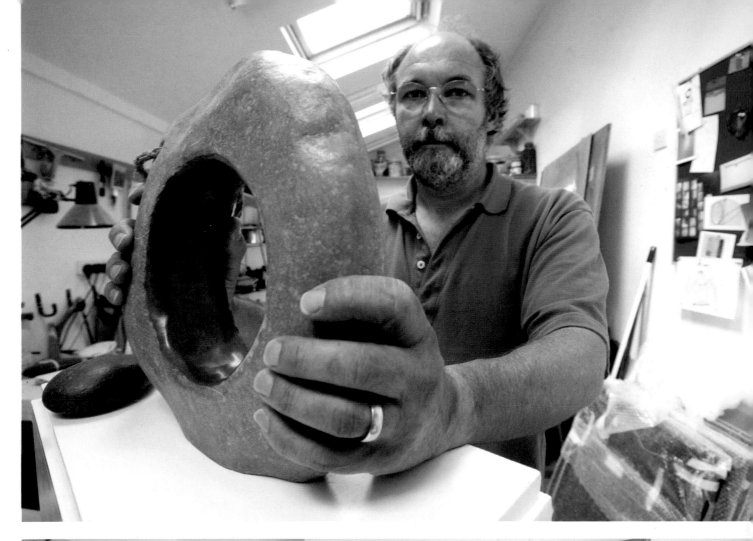

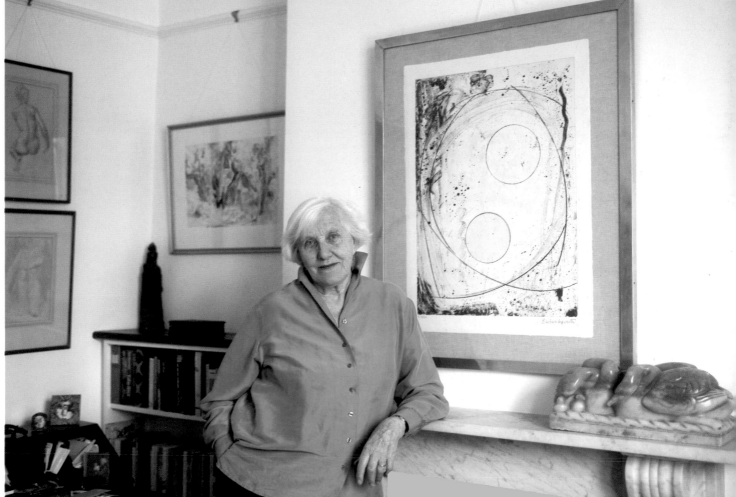

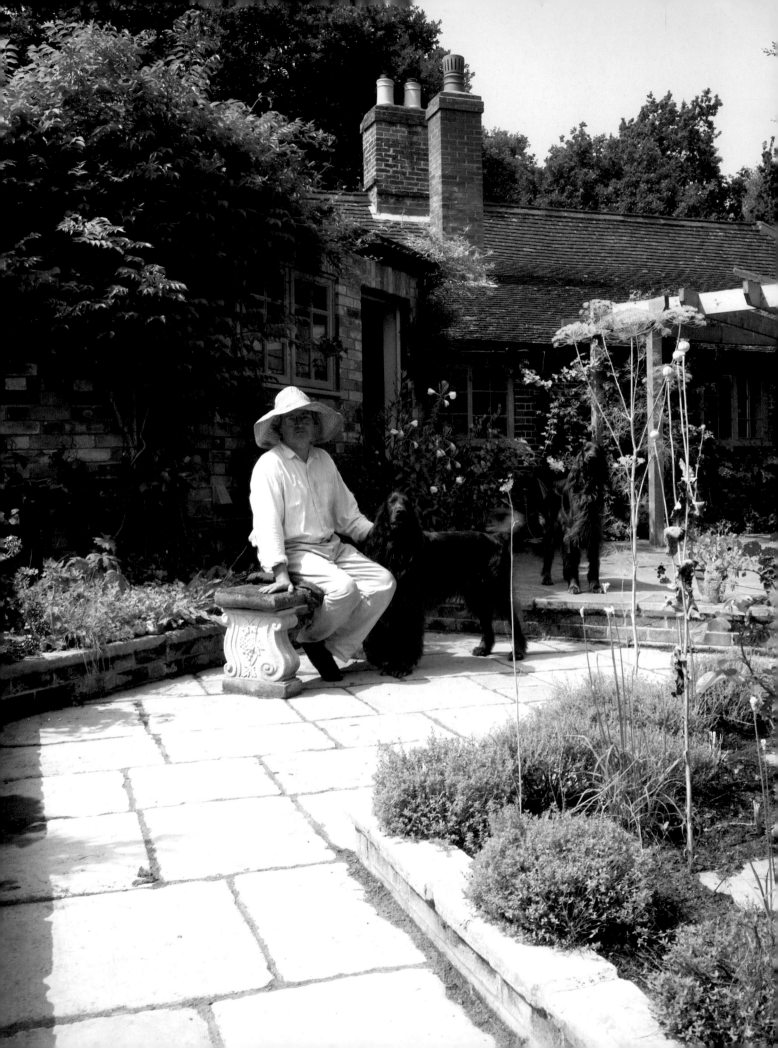

Opposite: In this shot I wanted to show as much of the garden and house as possible without losing sight of the man and his dogs. The path makes an interesting foreground composition that leads into the picture with the man as the centre of attention, while the house in the back-ground completes the picture of an idyllic rural existence.

Above: This portrait was taken with a telephoto lens with an aperture of f2.8, which reduced the depth of field and put the background out of focus. Shooting in this way emphasizes the subject, as it eliminates any distractions or intrusions that might appear if the background is in sharp focus.

Portraits: Daylight

For many photographers, daylight is the natural light source for photographing people. However, because it is ever-changing, a certain amount of forethought is needed. For instance, you may pose your subject against a suitable background, with the sun in just the right position, but exactly at the moment you are about to take the shot, a cloud obscures the sun. Depending how long you have to wait for the cloud to disperse, the sun could be in a totally different position by the time it comes out again, and the shot that looked so good before has now gone.

Sometimes direct sunlight can be so bright that it is uncomfortable for your subject. If this is the case, try composing the picture so your subject faces away from the sun. Remember to compensate in exposure, as the camera's exposure meter might record for the light coming from behind, not the light falling on their face. This can also be a problem when posing people against certain backgrounds – for example, when posing a fair-skinned person against a very dark background.

It is possible for the camera's exposure meter to take its reading from the background and overexpose your subject's face; this results in a very bleached-out look, and the detail can be lost permanently. The reverse is true when you compose a portrait of a dark person against a light background: here, the camera's exposure meter can read the background and underexpose the person, resulting in a silhouette. Again, the detail can be lost forever. This is why a handheld exposure meter can be a real asset when shooting portraits, as you can move in close and take an incident light reading. In this case you point the meter to the camera and read the light falling on your subject, rather than the light reflected from it.

When composing outdoor portraits, look out for the patterns that light can make, which can greatly enhance the shot. Such patterns can be created by sunlight filtering through the leaves of trees, or a pattern on the ground that may be made by the sun coming through a door or window.

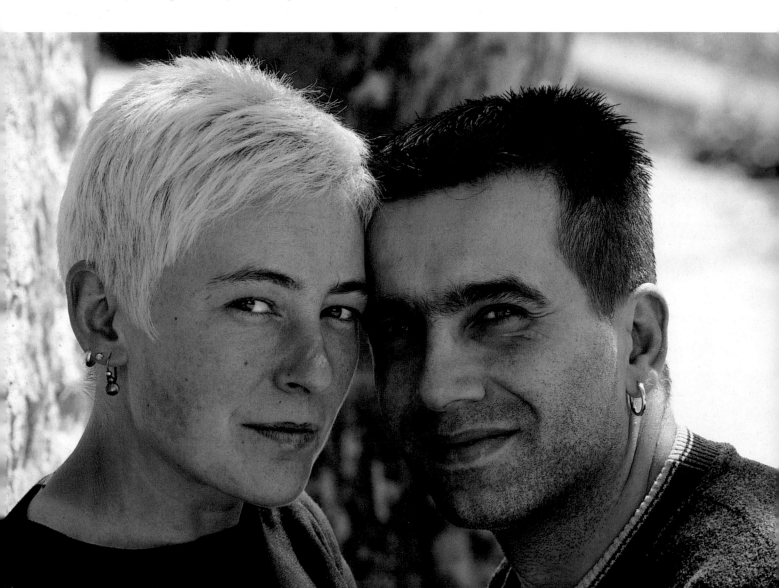

Opposite: When shooting portraits in bright sunshine, contrast and harsh shadows can be a problem. I moved the couple into an area of overall shade so that the light would be even on both their faces. Another point to watch when photographing more than one person is that they do not cast shadows over one another.

Below: The background plays a key element in this portrait of a French garlic seller. I cropped in tightly and composed the portrait so that he was just off-centre, and placed a small white reflector just out of shot under his face to give a little more light.

Right: I wanted to show the movement of people walking across a bridge. Having chosen my viewpoint I put the camera on a tripod, to keep the bridge sharp, while using a slow shutter speed to get movement into the figures.

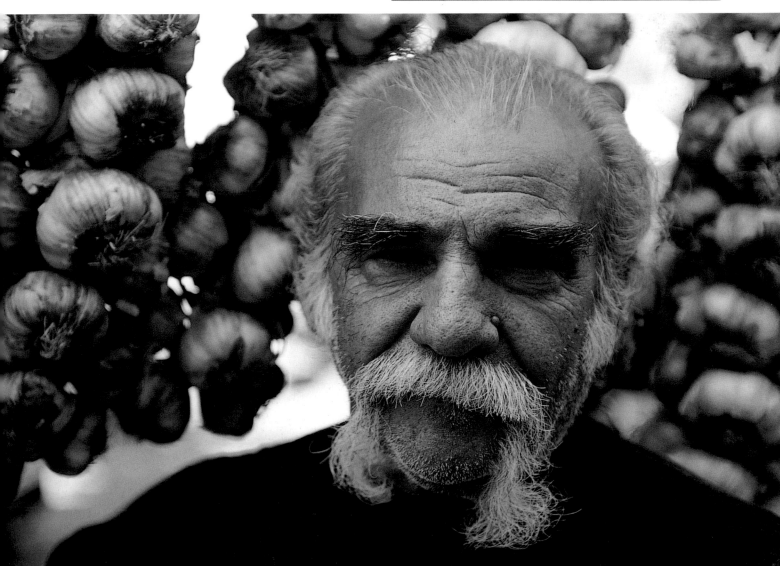

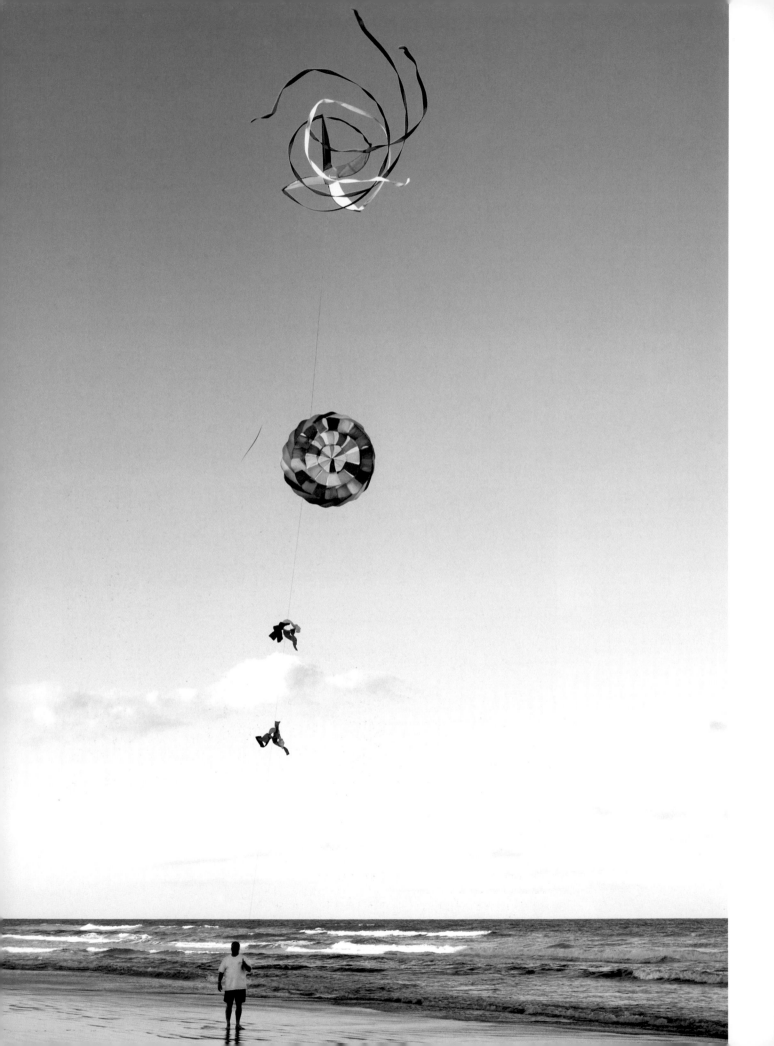

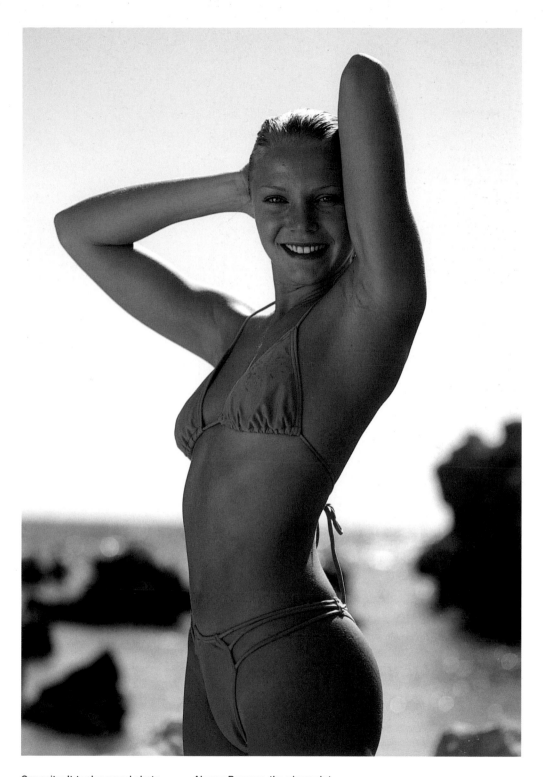

Opposite: It took several shots before I was satisfied with this picture of a man flying his kite. The great benefit of digital photography is that you do not waste money on expensive film and prints: you can edit as you shoot until you are sure you have the right shot.

Above: Because the viewpoint was low in this portrait and the sky was very bright, I used fill-in flash to even up the exposure. Without this, or a reflector, the girl would have come out as a silhouette; if I had exposed for her, the background would have been burned out altogether.

Portraits: Available Light

Available light refers to the light the photographer can use without having to supplement it with an additional light source. This type of light can come through a window or doorway, or be created by a table light or candle, or even street or shop lighting. The benefits of composing shots with this type of light are that it can be wonderfully atmospheric and the setting of a particular mood can be much easier to achieve than if you were to use an artificial light, such as flash.

Because the light is probably lower than full daylight or flash, it might be necessary to use a faster film with a higher ISO, or to adjust your digital camera's ISO to a higher setting. This will increase the grain, or noise, and you can use this change to your advantage, as grain can make a shot look atmospheric. If the light is really low, you may need to support the camera on a tripod, or use other means to keep it steady.

If you are working with ordinary domestic lighting, use tungsten-balanced film, otherwise all your shots will come out with an orange cast. If your camera is already loaded with daylight film or that is the only type you have, you will need to place an 80A filter over the lens. This is dark blue in colour and will correct the orange cast. If you shoot in fluorescent light, pictures come out with a green cast; use a filter over the lens to correct this. The problem here is that there are many different types of tubes, so finding the right filter can be a process of trial and error. Digital cameras can be set to auto white balance in these situations or, depending on your model, you should select the appropriate white balance setting from the menu. Of course, you can download or scan shots into your computer and correct the light balance there.

If you compose your picture with your subject near a window where the light is quite strong and directional, it can help to diffuse it by placing tracing paper or a thin material, such as muslin, over the window to create a much softer light. However, it may still be necessary to use a reflector on the shadow side, if there is not to be too much contrast in the overall composition.

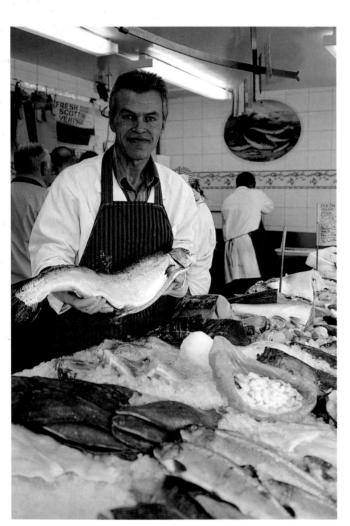

Left: Mixed light sources can create problems when shooting in colour, especially with film. In this case the light was daylight, coming in through the shop window, and fluorescent light from the ceiling of the shop. I decided that as the available daylight was the predominant light source, I would not use a filter to correct the green cast caused by the fluorescent light. Although there is a slight green cast, I felt that this would be acceptable. If I had been shooting digitally, I would have set the camera to auto white balance rather than the daylight balance. I am always amazed at how well my Canon 1DS copes in these situations.

Opposite: This shot of a renowned French chef was taken in the busy kitchen of her restaurant. The light was a mixture of daylight, fluorescent and tungsten lighting. Because this could have been a problem shooting in colour, I took the portrait in black and white.

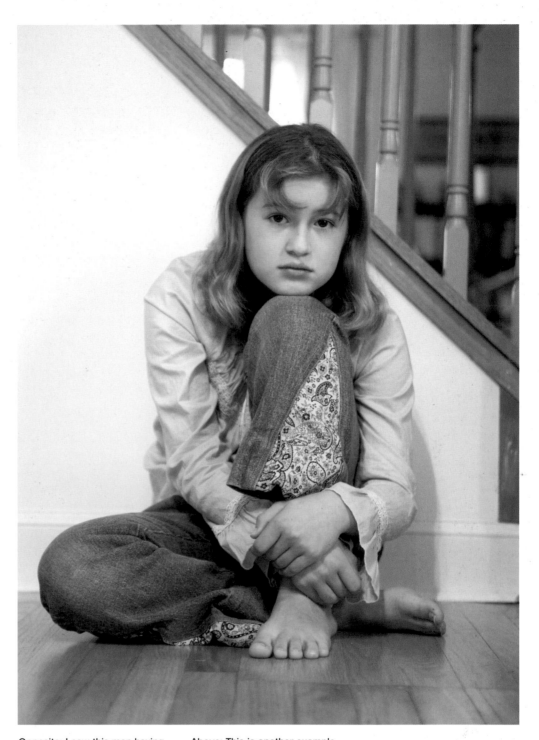

Opposite: I saw this man having a pint in Dublin. He was sitting at the bar, and the light was coming in through the doorway. Although I did not have a reflector, there is enough detail in the shadow areas, and the ambience of the surroundings has been retained. If I had used flash, this feeling would have been completely lost.

Above: This is another example of available daylight. I deliberately chose a low angle, as I liked the perspective created by the floorboards. A reflector was placed to the right of the girl, which helped to soften the shadows on the wall behind.

The Body

Before you attempt this type of photography, consider what style of body pictures you want to achieve. In addition to studying other photographers' work, it can be useful to study the work of painters, as even the most abstract or expressionistic painting can lend ideas for composition, light and line. Do not be afraid to copy directly some of the poses and angles of other photographers – some that look graceful, sensual and simple are often difficult to achieve, and only experience will help you get it right, by which time you are likely to have developed your own style.

When composing shots of the body, a more important consideration than the actual camera equipment is the quality of the light. Whether it is artificial light or daylight, the way you control it determines whether your pictures of the body are striking or mediocre. With artificial light, such as a single studio flash unit, you can achieve an astounding variety of effects. A single light placed almost directly behind your model draws the most revealing line along the contours of the body. Bringing the light further round, so it is almost directly to one side of your model, produces strong shadows. Again, with careful positioning, this strong, directional light emphasizes a variety of different body areas, from a woman's curved breasts to a male model's flat stomach. With the light source brought further round so that it is now close to the camera and directed through a diffuser, an almost shadowless, soft light is the result. Printed as a high-key picture, the result could be a highly romanticized image of sensuality.

Posing your models and positioning them into the sorts of sculptural shapes that will look glamorous or erotic in your final compositions is an area where experience really counts. In addition, the rapport between photographer and model is very important in photographing the body – on a shoot, it can be the model's input, as much as the photographer's, that can keep the momentum going. Finding a good model, or models, who you can work with in this way can really help in developing your own style of erotic or glamour photography.

Left: I originally took this shot with the pregnant woman standing, but when I came to do the print I thought it made a stronger composition to turn the image through 90°. The addition of her husband's hands creates a very intimate study.

Opposite: Often it can be just one section of the body that makes an effective picture. I noticed this model's shoulder and arm while shooting some full body pictures, and cropped in close. This detail of his toned body works well and makes an effective image presented in black and white.

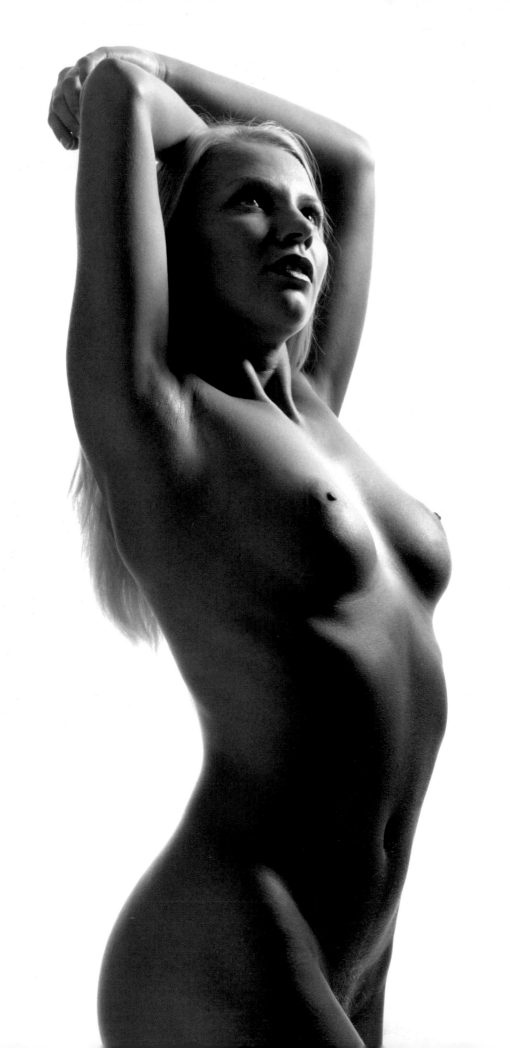

Opposite: I chose a low angle to achieve this shot, which provided a sculptural quality. I used backlighting and then placed a reflector to the left of the camera to bounce light back onto the model's body and give good definition. Her pose accentuates her graceful curves.

Below: This male nude shows tremendous strength of form, and the choice of pose emphasizes the classical nature of the shot. The background was deliberately kept white so that there would be no distractions, and the model was lit with just one light, with two others on the background.

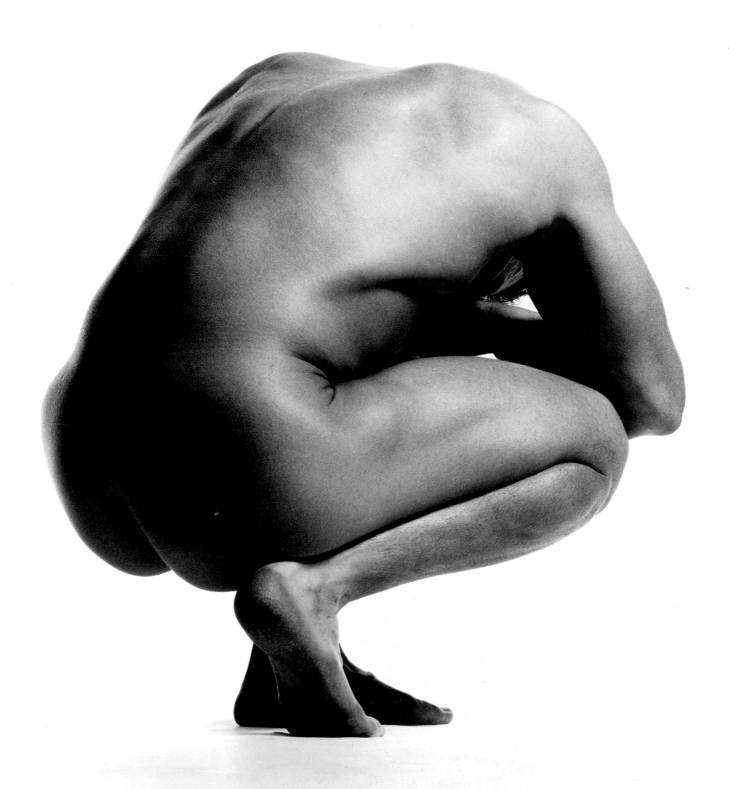

Work

Because work is something that most people in the world are involved with, it seems only natural that it should be fertile ground for the observant photographer. What is fascinating is that for many people work is nothing but drudgery that they feel trapped in, and it thus seems ironic that, if you were to fly those same people to another country – not necessarily that far away – they would invariably become fascinated by watching others working. In some cases the work might not be that different from what they are employed in at home, adding another layer of irony.

Perhaps the most important consideration when composing photographs of people in the workplace is the viewpoint – is it to be straight on, or would the shot be better taken from a higher or lower viewpoint? A lot depends on the background: if it is unsuitable, see if you can move the subject to somewhere more appropriate to the shot you have in mind. Then there's the light: do you need to move or turn the subject around to take advantage of the available light, or can you better

position yourself to do this? Perhaps you need to use some fill-in flash or get someone to position and hold a reflector to bounce light back into the areas that require it. Do you need props? Are the subjects using tools in their work, or is a hands-off shot required? Whatever the situation, you can get some movement into your shot.

If you are doing a more formal shot, perhaps indoors, how is it going to be lit? If you use the camera's flash, is it powerful enough, or might it create an ugly shadow behind your subject? If you include the whole room, maybe with the subject in the foreground, can you light the rest of the room without your lights being seen, or is the ambient light enough? If you use the room lights as the main source, with tungsten-balanced film, do you have a correction gel to put over the flash if you need some fill? If not, the subject can come out looking very blue.

All these questions may seem like a never-ending list of problems, but many of the answers – filters, gels, flashgun and so on – can be carried in a camera bag with the rest of your kit.

Left: While in Provence, France, photographing a restaurant for a book, I noticed this chef cooling what he had just cooked. It was early on a spring morning, and the light was crisp and clear. The spontaneous shot needed to be taken quickly, as the chef was soon back in his kitchen.

Opposite above: Time waits for no one: I liked the idea of portraying people going to work in the morning with a certain amount of urgency in their stride. I held the camera steady on a wall and focused on the clock. Keeping the depth of field to a minimum and using a slow shutter speed added a sense of movement.

Opposite below: These women were working in a rice paddy in India. Their happy smiles belie the fact that the work was hard and long. Their fellow workers in the background add to the overall composition, and using a medium telephoto lens ensured a tightly cropped picture.

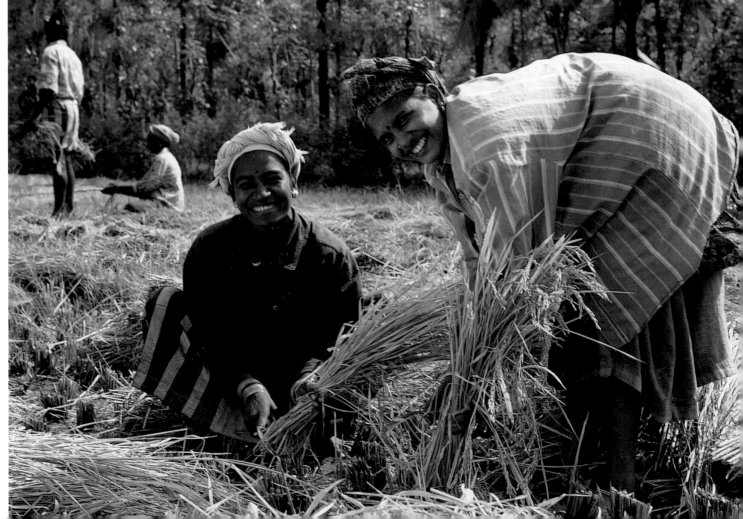

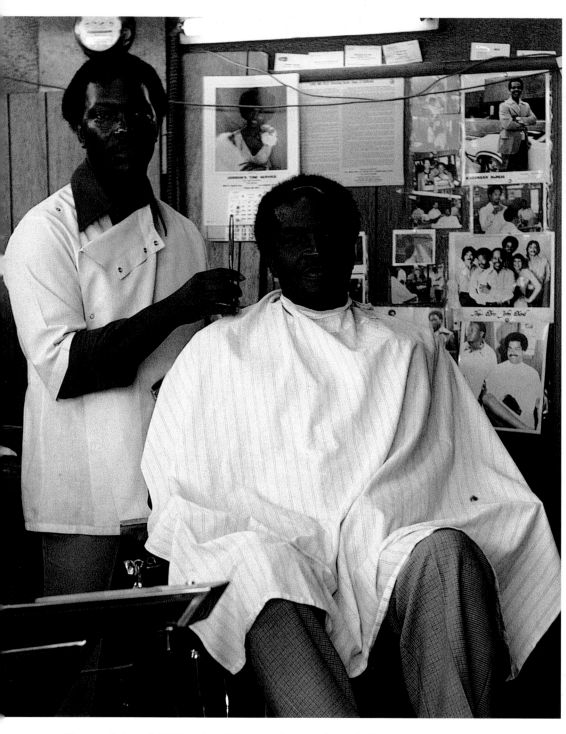

Above and above right: These two pictures are from a series on barbers across the USA. My concern was to avoid making the shots look repetitious, but at the same time to build on the theme. The most important aspect was to get all involved to look relaxed and natural while showing as much of their working environment as possible.

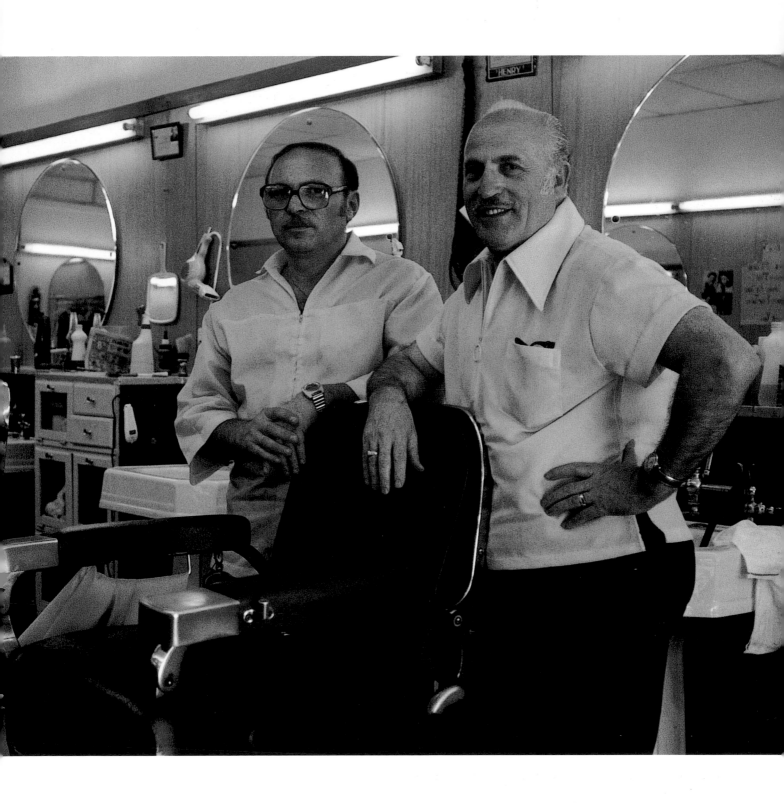

Buildings: Exteriors

Buildings are fertile territory for photographers – in addition to what is in your own neighbourhood, there are opportunities for new architectural challenges both in your own country, often close to home, and abroad.

Vernacular housing, industrial buildings, ancient churches, stately homes and modern architecture can, in some areas, all be found within a short distance of one another. As with so much of what is on their own doorstep, it is all too easy for people to walk blindly by, thinking that they have seen it all before. For the photographer, however, each day can present a new way of seeing what to many is too familiar to notice.

To begin with there is the light. In the early morning, the shadows will be longer and the highlights harsher. From dawn until dusk the sun moves across a building, bathing it in changing light and altering the shadows. This does not happen just throughout one day – the sun's position changes throughout the year, rising and setting in different positions on the building and forming different angles to the shadows. This means that no two days are ever the same. Added to this is the possibility of the building being illuminated at night, which provides a further dimension for composing stunning photographs. Another point to consider is urban pollution, especially the carbon monoxide emitted from vehicles. In certain cities where congestion is constant throughout the day, this can be a real problem.

Your viewpoint also changes the building's appearance. With tall, modern buildings, a low viewpoint with the camera angled upwards greatly exaggerates the feeling of height. This is because the sides of the building appear to taper (see page 64). Although converging verticals can be corrected with a PC lens or in the computer at a later stage, they can also add dramatic effect to architectural photography. If you choose a viewpoint so that you are looking down the side of the building and shoot it with a telephoto lens, it appears to compress the building and reduce the perceived space between columns or other vertical structures. Experimenting with different lenses from the same viewpoint can alter the composition dramatically.

Viewpoint

These three shots of Renzo Piano's NeMo building, at Oosterdok, Amsterdam, show how important it is to chose the right viewpoint especially when the day is dull and overcast. Although you can see the references to shipping in the building's design, picture (1) lacks impact and is generally dull. This is not helped by the weather. In picture (2) the entrance bridge helps fill the frame but cuts across the bows of the building, diminishing the naval references. In picture (3) I changed sides and took the shot from the other side of the bridge. The walkway now dramatically leads the eye into the picture and fills the whole of the right-hand side thus blocking out most of the dull sky. The bows of the building are now unobstructed and the overall picture is more dramatic.

Right: This shot was taken with the camera pointing straight upwards. The contrast of the whitewashed walls against the radiant blue sky works well. Always be on the lookout for an unusual angle, and always try to look at what is above and below you, as well as what is right in front at eye level.

Above: The symmetry of this French château lent itself to being photographed straight on. To keep the sides of the building straight I used a shift lens (see page 66), but could have corrected any converging verticals in the computer later (see page 68). The blue sky with its wispy clouds made a good backdrop and slightly softened the shadows, which could have been quite harsh on the window shutters had there been a completely clear sky.

Above: I deliberately shot this office building half an hour after sunset, when the sky takes on a deep blue that only lasts for about ten minutes. There is a feeling here that the building is projecting itself towards the camera, and its different levels make a strong architectural and photographic statement.

Buildings: Interiors

When photographing the interiors of buildings, there is often a tendency to try to get as much in as possible, and to use the widest-angle lens available. While this might be appropriate with some viewpoints, with others it can be detrimental to the overall composition.

For instance, if you are photographing the interior of a cathedral or other large structure and choose a viewpoint where you look down the length of the nave, using an ultra-wide-angle lens gives the effect of "stretching" the shot, which can make it look as though you are viewing the scene from the wrong end of a telescope. On the other hand, when photographing a room of more modest proportions, using a wide-angle lens can give the appearance that both the ceiling and the floor are at extreme angles to the walls of the room. Both these situations create poorly composed pictures. On the other hand using a fish-eye lens – the most extreme wide-angle lens you can get – to photograph the decorative ceiling of a cathedral can create a stunning composition (see page 44–45).

The other area that needs to be considered when photographing interiors is the light. Very often the available light coming in through the windows or door of any room, however large, is inadequate for photography; this is often because the light is uneven, leaving one side of the room in deep shadow, and probably means that some form of fill-in flash is required to balance the illumination in the room. If you are using the room's own lights, which are probably tungsten, might they get burned out while you expose for the rest of the room? This does not look very attractive or effective, and again some form of fill-in flash may be required.

In addition to developing an eye for successful compositions – which comes with experience – knowing what equipment is appropriate in different situations is the most important step in seeing pictures that are compositionally first-rate. There is no point in buying more and more expensive equipment unless you can see how it can be used effectively again and again.

Left: The inside of this tower makes a strong geometrical design, and the filtered sunlight creates interesting patterns. I shot off-centre, as this gave a greater feeling of height than if I had shot it straight up. The texture and colour of the main beams contrast well with the outer slats.

Opposite: This vast exhibition hall at the Kennedy Space Center in Florida houses a full-scale Saturn 5 rocket of the type that took astronauts to the Moon and back. The shot had to be taken with available light, which was from a mixture of different sources. The camera's white balance was set to auto and coped excellently, considering the difficult circumstances.

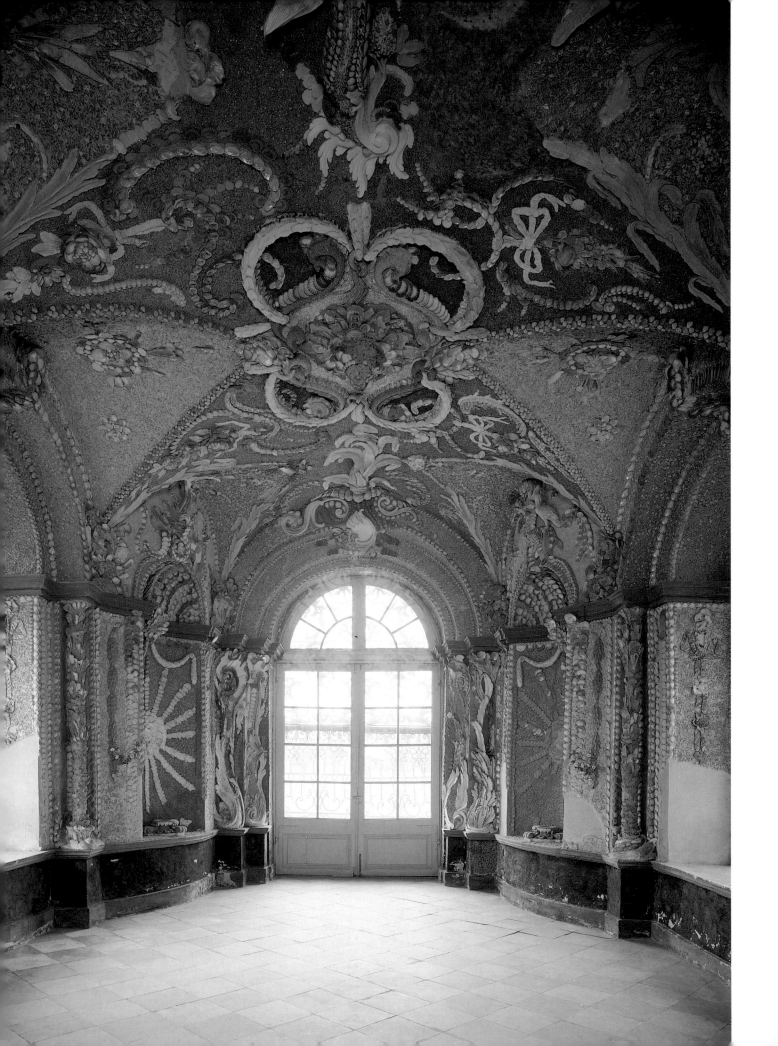

Opposite: This small summer house, in the grounds of Kuskovo Palace in Moscow, was shot using an ultra-wide-angle lens. In situations such as this the lens can create a false perspective, with the ceiling and the floor looking as though they are at steep angles to the rear wall. However, in this case a sense of proportion has been retained, and the decorative shell-work shows up well.

Above: In this interior, the problem was to keep fill-in flash from reflecting into the mirrors that the camera is facing, and to have it on just the right power so that the room does not lose the feel of only being lit by daylight.

Right: This modern apartment was bathed in strong daylight, and I wanted to catch the pattern of the light coming in through the industrial windows before it either moved or disappeared behind a cloud. Unlike artificial light or flash, daylight is constantly on the move, and you need to be quick-witted to take full advantage of its potential.

Buildings: Details

In addition to the overall, big shot of a building or a stunning interior, there are many other architecture-based shots that can make great pictures. By themselves they might not be particularly eye-catching, and because of this they are often overlooked or disregarded, but it is amazing how effective they can be when put together in a series or collage.

The pleasure of focusing on architectural details is that the fine design and craftsmanship at the top of a Corinthian column, for instance, can become completely lost in an overall shot. By going in close you can highlight the intricacies of the carving, the interesting shadows cast and other details of the workmanship. When you are displaying a set of finished photographs, these shots can balance and enhance the overall view.

When it comes to presentation a collection of detail shots from different buildings can make an interesting mosaic or collage. A collage can be made from several prints of one photograph: have half the prints made back to front. When they are mounted together, they produce a kaleidoscopic effect.

However, it is not always as simple as getting in close on some detail: if you are photographing stained glass, in a church or cathedral, for example, you need to read the light coming from behind the window to ascertain the correct exposure. Because coloured glass reduces the intensity of the light coming through it, you are likely to need to use a long exposure, and you should make sure you use a tripod to support the camera. Here, the other necessity is to make sure that the camera is correctly aligned, otherwise in the final shot it can be apparent that the photographer has gone to the trouble of getting the correct exposure, only to have the window sill tilting one way and the window leaning over. Whatever method you use to photograph stained glass, don't use any kind of flash, as the stained glass will not record at all.

Details can also provide a touch of humour in your photographs. Look out for unusual gargoyles and other sculptures, or move in close, cropping out unwanted details, to emphasize particular features.

Left: This shot was taken while I was walking through a village in the far south of Italy. Although it is a simple piece of detail, the winding staircase conjures up a feeling of mystery and the unknown. The rug on the washing line adds a splash of colour, and the overall feel is of an extremely painterly shot.

Opposite: In contrast, this detail of a gigantic Japanese sculpture looms over the camera with immense power. The size of the figure is exaggerated by using a wide-angle lens and a low viewpoint. The feeling of enormity is further enhanced by the deliberate inclusion of two people walking in the background.

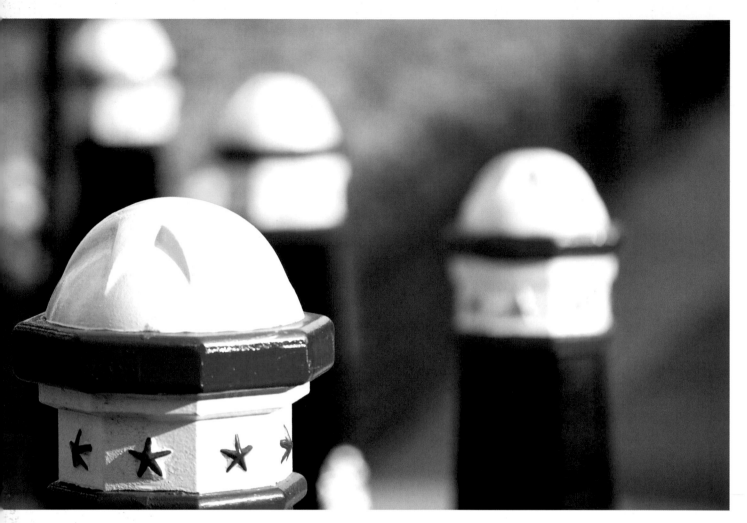

Above: I liked the way that the tops of these bollards made such a strong composition, both in terms of distribution throughout the frame and brightness against the background. However, is the key to success the way that the depth of field is kept to a minimum so that only one is in sharp focus while the rest of the picture is in soft focus?

Opposite: In this detail of an office block window, you can see the distorted reflection of the building opposite. In situations such as this, where you are photographing into glass, water or a mirror, be sure to focus on the reflection and not the glass or the surface of the water or mirror, otherwise the reflection is likely to be out of focus.

Landscapes

When photographing landscapes, one of the most important aspects of the overall composition is the attention that is paid to the foreground. Interesting and attractive landscapes are all around us, but transferring how our eyes see a view to how it can come out as a photograph needs a little more thought and preparation than just pointing the camera at the horizon and hoping for the best.

Natural or man-made objects found in the foreground of a scene can be used to frame the overall picture or lead the eye into it, thus bringing attention to the middle ground. Having said this, if the foreground is badly or artificially composed or looks fussy and cluttered, this diminishes the overall impact of the picture and makes the viewer confused, as there appears to be no centre of interest.

A classic device that will both frame the picture and hide unwanted details is to use a tree in the foreground. Imagine that a sky is without clouds or colour and looks bland. Here, you can use the trunk of a tree as a framing device on one side of the

shot, and you can position yourself so that the branches frame the top of the picture as well, covering the bland sky and adding interest to the overall shot. By making the viewpoint higher or lower, you can get the branches to cover greater or lesser areas of sky until everything is in just the right position.

There are many other devices that can be used to create interest in the foreground of a landscape. A simple farm gate or wall can be shot so that it stretches across the whole of the picture, and choosing a position so that the gate or wall runs at an angle makes a more interesting composition than if it is shot running dead straight across the foreground.

You can also make use of colour and contrast to create foregrounds. Flowers add a splash of colour to the foreground, especially in spring. By choosing a low viewpoint and slightly pointing the camera down, you can use flowers to lead the eye into the middle ground of the picture, at the same time employing them as a device to reduce an area of uninteresting sky, which can otherwise dominate the picture.

Left: I chose a viewpoint in the centre of a row of vines so that the villa would be visible in the middle distance. The sun was coming over my left shoulder at 45° and created good shadow detail. A polarizing filter has retained the detail in the sky, and the gently rolling horizon line gives the composition added interest.

Opposite: A 250mm telephoto lens helped to compress this picture and make the tree, with its early spring leaves, stand out from the darker pine trees in the background. The swathe of wild yellow daises makes a great band of colour in the foreground.

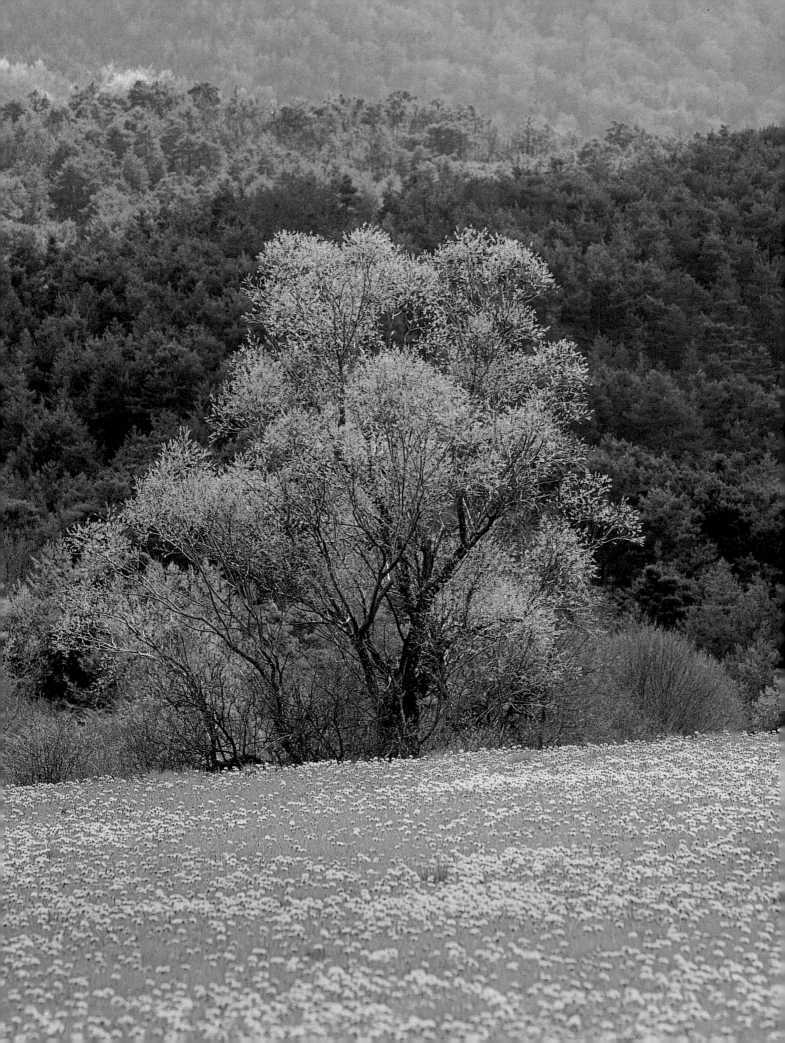

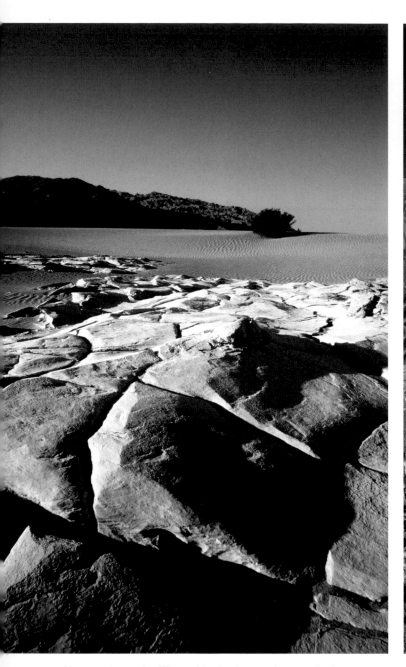

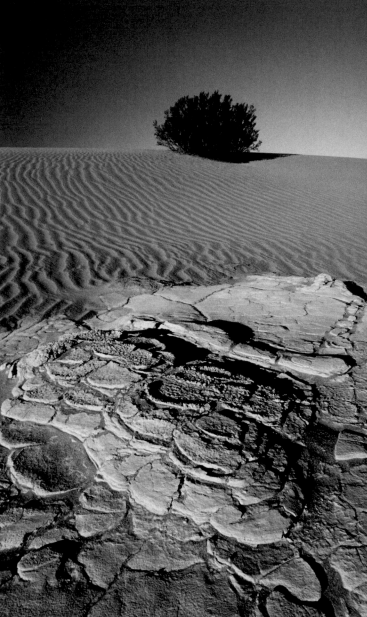

Above and opposite: When taking landscape photographs, I am always on the lookout for themes. When shooting in Death Valley, USA, I noticed numerous areas of dried and cracked sand. Some of these were quite small, but by using an ultra-wide-angle lens and getting in extremely close – in some cases I was only 30cm (12in) away – they dominate the picture.

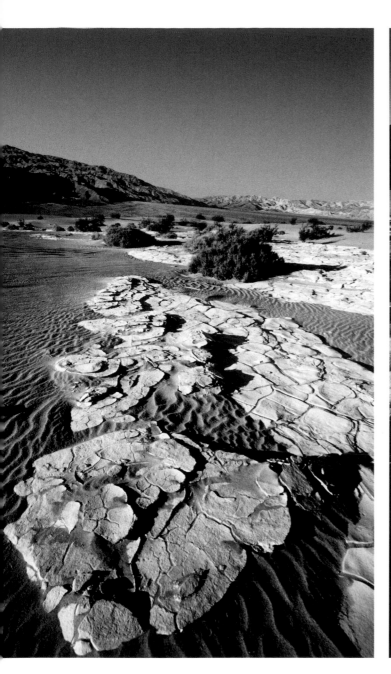

Rivers, Seas and Lakes

When composing photographs of a seascape, lake or river, it is all too easy to include a large amount of unwanted foreground detail. This could be a vast stretch of sand or pebbles with no discernible interest, or a great deal of dark, featureless water. This is especially the case when using wide-angle lenses, as the greater angle of view pushes the horizon further into the background. In these situations you should always remember the golden rule; foreground, middle ground, background. It may only be a matter of moving a short distance from your original viewpoint to improve the foreground composition; alternatively, a higher or lower viewpoint may be all that is required to include or crop out foreground detail.

Having seen the view that you want to photograph, consider it for a few moments with the naked eye. Look for an element of foreground interest that you can use to lead the eye into the rest of the picture – for instance, rocks in a river that make an interesting formation, or the branch of a tree that you can use to make a foreground framing device. If a beach is fringed by trees, these can be put to good use to frame one side of your picture. What about the sand itself? Does it have interesting patterns formed by the wind, or any undulations that might resemble a desert if shot from a low angle? If you are up high, such as on cliffs, can you find a headland to lead the eye into the shot? The important point to remember is not to let these elements dominate the picture, but to use them as visual tools to enhance the overall composition.

Consider whether the picture would look better framed as landscape or portrait. Remember that with the camera positioned in portrait mode you will include more foreground and more sky. If there is a great deal of sky in your picture, would it help to use a polarizing filter? With the sun in a favourable position, this filter helps to enhance the blue of the sky and bring out any cloud detail, and also has a similar effect on water and any reflections.

Left: Sometimes it is the exception rather than the rule that makes a picture work. In this shot of the Corinthian Canal in Greece, the subject has been placed in the centre of the viewfinder. However, all the elements of the Golden Section, (see page 38) are at work. Even the passing passenger train, perfectly centred on its track above the canal, emphasizes the strong lines of symmetry.

Right: Placing this horse and cart on the right-hand side of the frame gives balance to this shot of a deserted beach in Tunisia. The strong mid-afternoon sun creates excellent shadow detail, and the blue of the sea and sky complement each another.

Right and opposite: Standing on the river bank for the shot at right meant that too much water filled the foreground. By wading out into the river (opposite), I found a viewpoint where the foreground rocks help lead the eye into the rest of the picture.

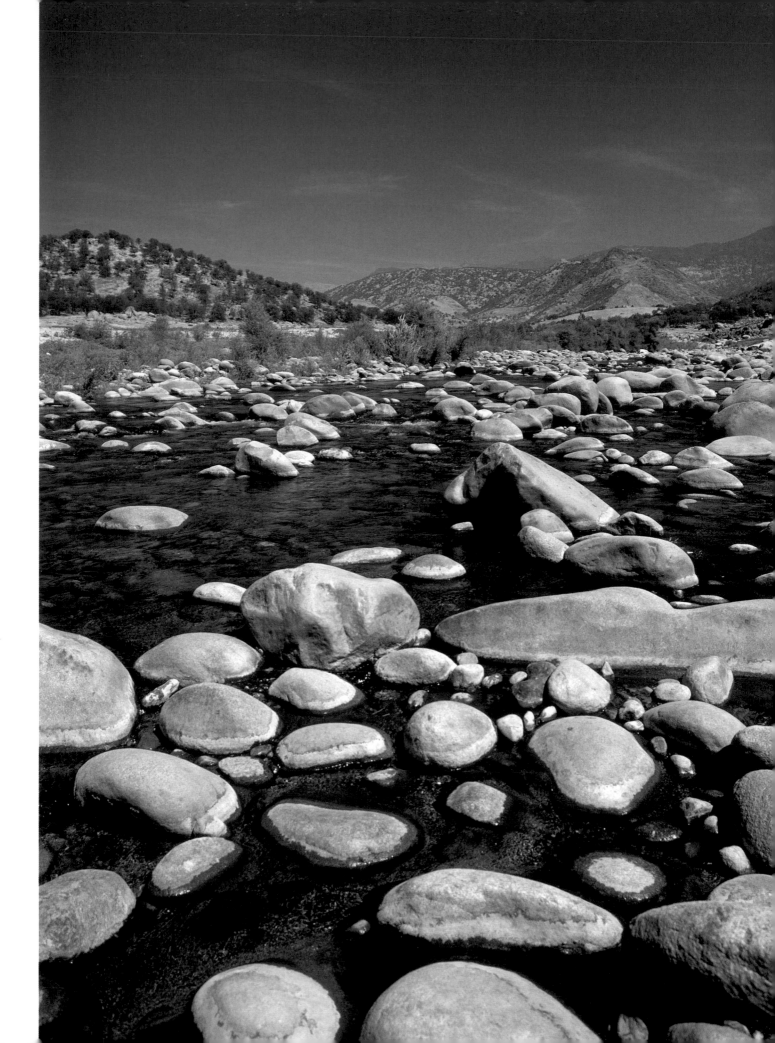

Right: For this shot I used
the polarizing filter. This has
intensified the blue of the sky
and given greater clarity to the
clouds. It has also enhanced the
quality of the sea by removing
the surface reflection and
revealing the different hues
according to the depth of water.
The linear composition echoes
Mark Rothko's abstract
expressionist paintings.

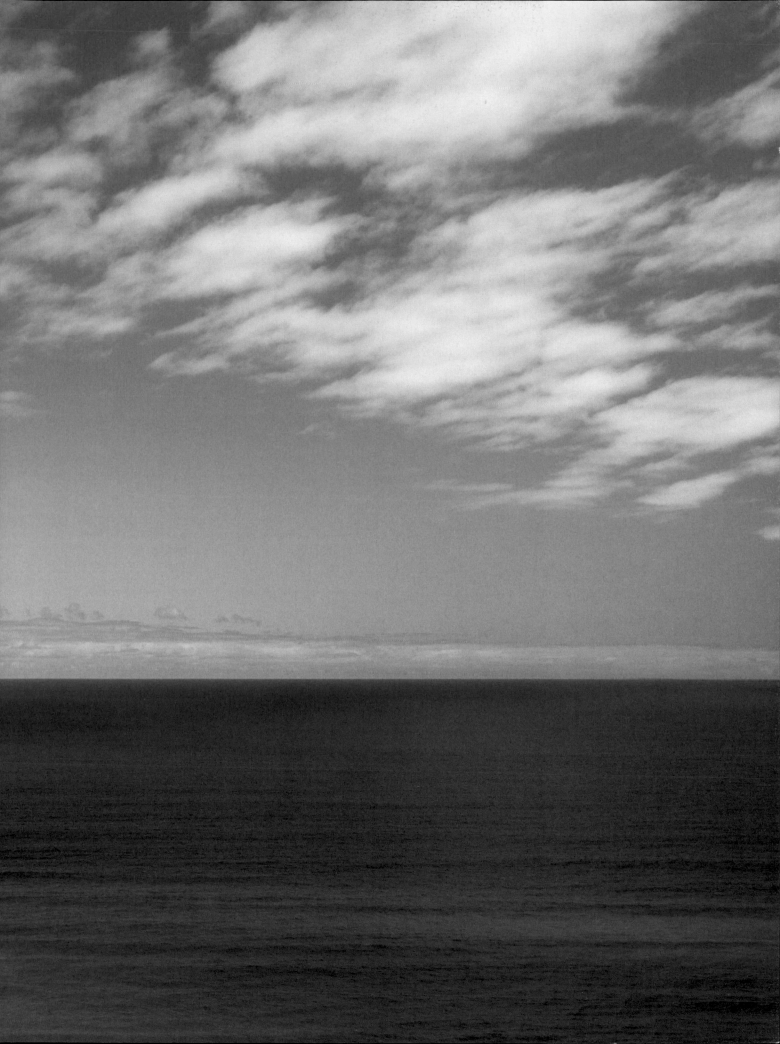

The Weather

For most of us the weather is a constantly varying aspect of our environment. Although it might appear that bright sunshine is necessary for good photographs, rain, fog, mist, snow and frost provide many opportunities for great pictures. Many of these opportunities occur without any forewarning – another very good reason for carrying a camera with you at all times.

Although pouring rain makes it difficult to take pictures, you can take advantage of many other aspects of wet weather. Distant clouds, from which you can clearly see rain falling, can look very impressive if caught in the right light. If the rain clouds are some way in the distance, you may need a telephoto lens, but if the rainstorm is not so far away, you can use a wide-angle lens from a low viewpoint to make the sky more prominent and produce an equally dramatic composition.

After the rain has stopped, seek out puddles or flooded areas that might have interesting reflections. Check the viewpoint options, since just a step backwards or forwards, or a higher or lower viewpoint, can make all the difference to the reflection and how much you see of it.

Framing and cropping also play a crucial part in the overall composition. Remember that with pictures of reflections you need to focus on the reflection and not on the surface of the water. If you focus on the surface it is quite likely that the main point of interest in your shot will be out of focus. This could easily be done with an auto-focus camera as the sensor could focus on something like a leaf or twig floating on the puddle.

It is possible to get very atmospheric pictures in misty and foggy conditions, unless they are too thick. Again. you may have to use a manual focusing setting, as auto-focus cameras can have trouble focusing in such conditions. A tripod may prove invaluable, as the light is probably going to be quite low. If you are shooting on black-and-white film, a yellow filter will help to bring out the definition in a cloudy sky, while a red filter will increase the foreboding in a stormy sky.

Left: Early mornings can frequently be misty, as is the case here. The sun can be seen just trying to break through, and its rays provide the interest for this picture. This kind of weather can vary considerably in a very short space of time, so you need to be in position and ready to take advantage of the best moment for your shot.

Opposite: Very often, especially in summer, rain can clear the air and leave the sky crisp and blue. The freshness of the green landscape here contrasts well with the sky and clouds, which were enhanced by using a graduated neutral density filter.

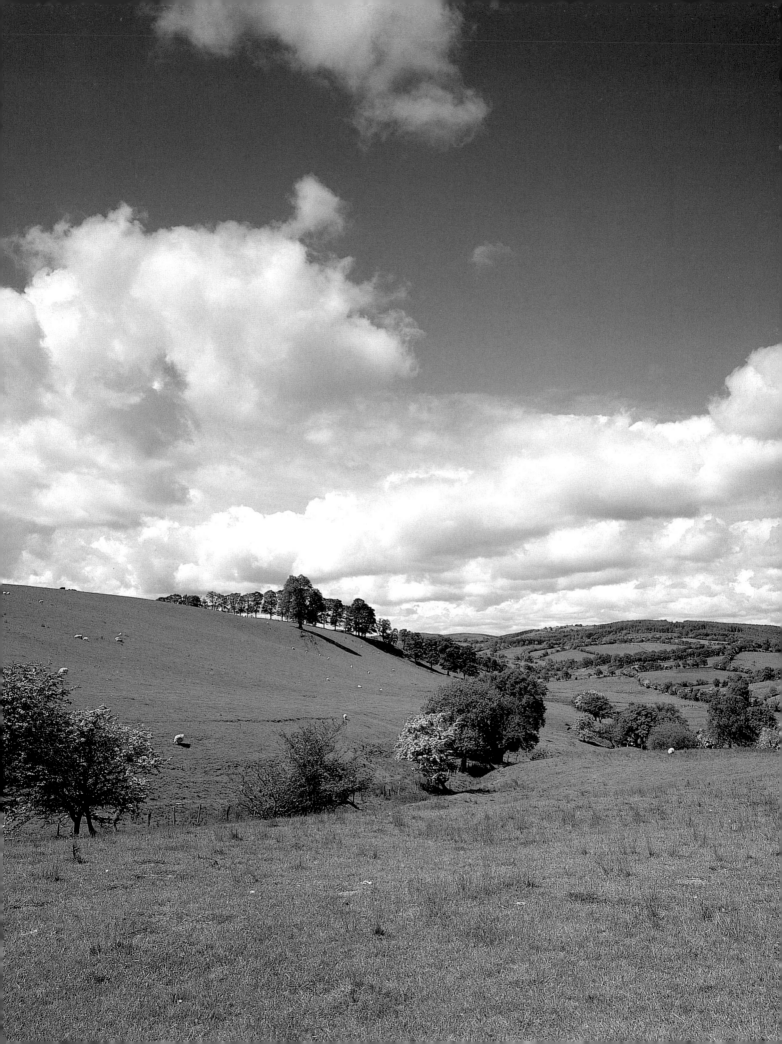

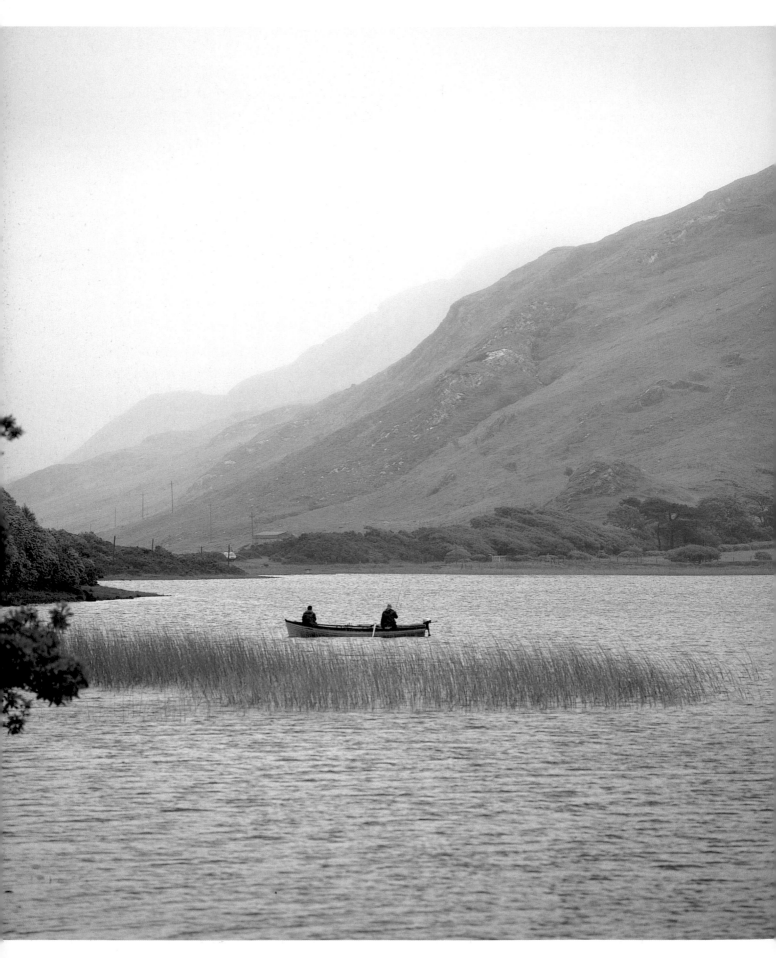

Left: Shooting in the rain can be difficult, not least because you need to protect your camera equipment. However, it is possible to get some atmospheric pictures, such as this one of two fishermen on Kylemore Lough, Ireland. A lens hood helps to prevent rain spots forming on the front of the lens.

Right: Overcast skies can form dramatic backdrops to your photographs, but you need to be quick, as light changes rapidly. I had just got off a train when I saw this sky and took the shot.

Below: The early morning sun was beginning to melt these icicles, and I photographed them just in time. I particularly liked the shadows that they made on the wall, and although this is a simple image, it makes a good graphic picture.

The Seasons

Just as changing weather can make great shots, so can the seasons. There are few places in the world where there are constant seasons with few variations, and you can use the changes to great advantage.

When taking pictures in winter conditions where there is a lot of snow, the sun and its position play an important part in the overall composition of your photographs. If there is no sun, pictures of snow can look dull and flat; but even if the sun is shining, this does not mean that you can just point the camera from any angle and get a good result. What you should be looking for when composing this type of shot is shadow detail – this can be the shadows created in the ripples of drifting snow, or a snow-laden tree casting its shadow on a blanket of freshly fallen snow. These shadows help to give your shot depth, so you need to choose your viewpoint carefully.

Spring, with its abundance of new growth, is the perfect season for photography – fresh, chilly mornings can provide clear blue skies without the haze that may be present in the summer months, and vibrant young flowers can create a carpet of colour in forest or meadow. When the sun is still low, the early-morning light creates the best shadow detail, and using a wide-angle lens can add great depth to your shots.

In a long, hot summer, haze can be a problem. If this is the case, try to find situations where you can crop out most, if not all, of the sky. The use of long lenses can help to compress the landscape and create interesting perspectives or isolate detail. If the sky is clear, great pictures can be obtained by using the minimum of detail, for instance a shot of the sky and sea where the compositional references have been taken from a painter such as Mark Rothko.

In the autumn, or fall, colour is the main ingredient of a striking composition. In addition to the juxtaposition of different coloured leaves, a low viewpoint combined with maximum depth of field can draw the eye into the picture and create a strong sense of perspective. Look out for deep blue skies that make a dramatic backdrop to richly coloured tree foliage.

Left: Spring provides a wealth of photographic opportunities, with an abundance of growth on trees and plants. The flowers were a magnet for the butterfly, and I took the shot with a 200mm lens and a 2x extender that gave me an effective focal length of 400mm.

Opposite above left: When shooting in winter snow, you need to be careful with exposure, as with so much brightness around, the camera's metering system can sometimes be fooled into thinking that there is more light than there actually is, and your shots can come out underexposed.

Opposite above right: In many seasonal pictures, you need to be quick, as the lifespan of many flowers is extremely short. These bluebells were shot in early spring, when there is so much new growth, but lasted for only a few days before disappearing.

Opposite below left: For this summer shot of sunflowers in full bloom, I took a high viewpoint and used a wide-angle lens so that I could focus on the foreground and still retain background detail. When the sun is so bright, be careful that you don't cast your own shadow over your subject.

Opposite below right: Autumn leaves make a vivid carpet of colour. To get this shot I got down low on the ground and used a macro lens to get close to the foreground leaves, which meant that I needed to stop right down so that I could keep the background as sharp as possible.

Above: Whatever the season, light makes such a difference to the feel
of a photograph. Here, the radiant blue sky and strong shadows convey
a sense of summer warmth and brightness.

Above: The same is true in winter. Without the blue sky and white clouds, this shot of a frozen lake covered in snow could have looked dull and overcast. The sun creates the shadow detail that makes the picture come alive.

Still Life

The great thing about shooting still-life photographs is the amount of control you have over the composition. If you are shooting indoors, for example in a studio situation, you have total control over the lighting as well. Because of this control, still lifes provide the photographer with great exercises in making a composition happen. Still-life photographs can be created using any items, and can be as simple or complicated as you want them to be.

A "studio" does not have to be a large room with a high ceiling, and you do not have to have a bank of different lights and large-format cameras to create effective still lifes. There is no reason why you can't create great pictures on the kitchen or dining room table just using one light – it really can't be emphasized enough that it is what you do with your equipment, not the quantity you have, that determines the result.

Because you are placing the items that will make up your still life in exactly the position that you want them, it is advantageous to have the camera mounted on a tripod, as in this way you can keep referring back to the viewfinder or LCD screen to check on the composition. The same goes for the lighting: each time you move a light source, it is essential to check the result from the camera's viewpoint. In this way you can see every change in shadow detail, as well as the intensity of the light as it is moved nearer or further from the subject. This is why a camera such as a SLR is such an asset. When you look through the viewfinder you are actually seeing what the lens is seeing, whereas with a compact camera there will always be a disparity, known as parallax error. The other advantage of a SLR is the array of accessories including extension tubes and bellows, which are not available with digital compact cameras.

A medium telephoto lens can also be useful when shooting a still-life photograph, as it not only allows you a certain amount of space between the camera and your set-up, but also gives room for you to position reflectors or mirrors to direct the light to the areas you want it to go.

Left: This still life was taken as part of a restaurant series. I took the salad outdoors and placed it on the top of a wall. The sun was strong on the background, and I used two small white card reflectors to bounce light back onto the glass. The shot was taken on a 150mm lens, and using a wide aperture of f2.8 meant that the background would be out of focus.

Opposite: Many still lifes can be created with a minimum of items: here, the leaves made an ideal backdrop for the apples. The old rusty containers just happened to be lying nearby, and the rich reds and yellows of the apples blend well with the leaves.

Above: The textures of the leaves and ribbon make an effective still-life photograph. I placed one studio flash unit fitted with a soft box at right-angles to the camera to bring out the texture of the objects.

Above: In contrast, I backlit these flowers and used a white reflector to the right of the camera to get light into the buds. I placed an extension tube between the camera and the lens so that I could get in very close, and opened the aperture as wide as possible so that the background would go soft.

3 Further Techniques

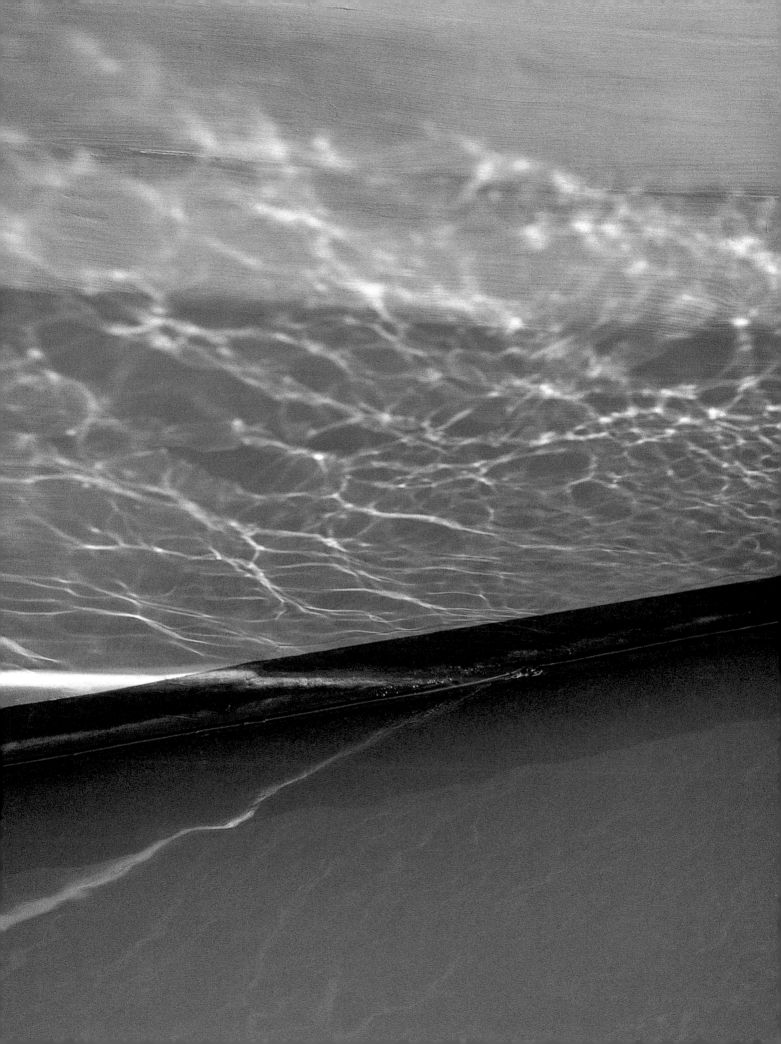

Building Panoramas

Some views, such as a mountain range or wide river, are just too big to be caught successfully in a single frame – even if you were to use an ultra-wide-angle lens to get the width of the scene, the background can end up pushed so far back that very little detail is readable. In situations like this, you should consider taking several shots across the scene, and then "stitching" them together on a computer to build them into a single panorama.

Most digital cameras come with a panorama-building program that can be used to create 360° panoramas; however, although under ideal conditions these programs give excellent results, more often blurring is visible where textures overlap, or where exposure differences are noticeable due to vignetting by lenses that are not of the highest grade.

When taking the photographs to build a panorama, you need to keep the camera level. For this reason it is best to work on a tripod with a pan tilt head so that you can evenly move the camera across your chosen view. Take as many shots as you feel are necessary – you do not have to use them all. Exposure is important, too, as you want the scene to be as evenly lit as possible, which can mean giving different exposures to the different shots. It might be an idea to bracket each shot that will make up your panorama and edit them later. If you are using filters, such as a polarizing filter, the effect it has on the sky will diminish or increase as you pan the camera. This could give the sky a very uneven appearance, as could also be the case if you are using a graduated neutral density filter.

Remember that in the northern hemisphere, if you are looking south the sun moves from left to right. Depending on the time of day, one side of your view can be in direct sunlight while the other is in shade. (The direction of sun movement is, of course, reversed in the southern hemisphere.)

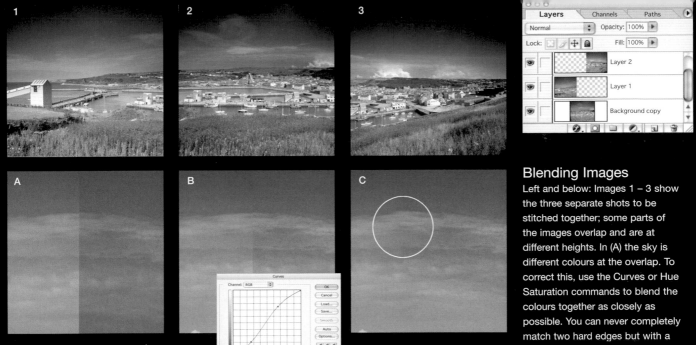

Blending Images

Left and below: Images 1 – 3 show the three separate shots to be stitched together; some parts of the images overlap and are at different heights. In (A) the sky is different colours at the overlap. To correct this, use the Curves or Hue Saturation commands to blend the colours together as closely as possible. You can never completely match two hard edges but with a large soft eraser, you can soften one edge, which will then blend into the other (C).

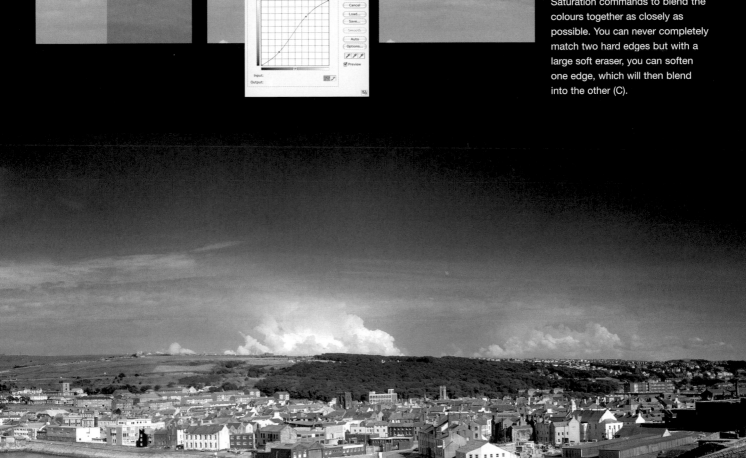

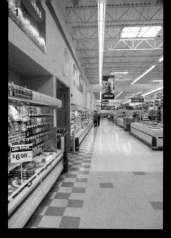 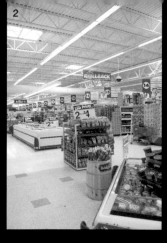

Checking for Detail

The image below a panorama of five individual shots. The effect would be almost impossible to achieve without shooting on an ultra-wide-angle lens, such as a fish-eye. However, with a fish-eye the sides of the image would curve and the background would appear to recede into the distance and detail would be lost.

I joined images 1–5 together using the panorama building software that came with my Canon camera, which automatically composites the pictures almost seamlessly. Note how the roof supports appear to curve, which is not the case in reality. There are two images of the word "Deli", which the software has corrected by itself.

5

6

7

However, even software cannot correct every detail, and in (6) the edges have been poorly blended. To correct this I cut and pasted a part of the original image to disguise the very obvious join (7). The end result (below) looks like a single-image shot, where only the most critical eye could detect the joins.

Digital Composites

How often has a potentially good shot been ruined because the weather was dull and overcast, or the background was inappropriate for the subject? These days, many shots that have suffered from faults of this type can be revitalized using a computer.

The first thing to consider when creating digital composites is that the two or more shots that you are going to combine must complement one another. This means that if you are going to replace the sky in a landscape shot, you need to replace it with one that has been taken from a realistic, believable angle. You also need to choose one that has a similar tonal range – for instance, if you choose a sky from a picture taken from a low viewpoint and use it with a landscape shot from a higher viewpoint, the results look compositionally wrong. Similarly, if you choose a shot with a bright, sunny sky and combine that with a landscape that has very little shadow detail, the finished picture cannot appear very realistic. However, new life can be given to mediocre pictures by using the right images.

Even in countries where the weather is more favourable, skies can be flat and uninteresting. This could be due to heat haze or pollution caused by traffic congestion. With this in mind, it is important not to give up on a shot just because one of the elements, such as the sky, is not how you really want it. Try to envisage it with an element of a shot that you have in your library already, or bear that in mind as you continue your journey.

With practice and by developing your skill, it is possible to shoot pictures specifically for making digital composites. One example is to shoot a person from a specific angle with the intention of having them look as though they are climbing the wall of a building that you had shot looking down from its upper floors on another occasion. In fact, the walls need not be from a building at all, but could be a shot of some other material, such as a piece of metal or a circuit board, that gives the final image a sense of the surreal. What you can create is limited only by the boundaries of your imagination.

Improving the Composition

Often it is not possible to wait for all of the ingredients that would make a perfect landscape picture to be in place. For example an overcast sky could remain for days, but by compositing two images, we can create a near perfect composition.

1 I always felt that this landscape could have been improved if the clouds had not been quite so dense. By compositing the sky from another image, I transformed the original into a far better picture in which the clouds now add a greater depth (right).

2 It is important to select an image where the cloud formation blends in with the landscape and has similar tonal ranges. Remove any blemishes from the two elements; tonal and colour adjustments can be made once the composite is complete. Erase the sky from the main image, and replace it with the alternative sky on a new layer.

3 Having transferred the new sky, you can enlarge or reduce certain parts of it so that it looks convincing and fits perfectly. Some parts of the sky might have to be cloned or rebuilt. It can help to make the main image semi-transparent to aid accurate positioning.

4 The more intricate parts of the sky can be selected easily with the Magic Wand tool, then removed. Some areas might need to be removed with the Eraser tool.

5 The two sections of the picture now need balancing using a combination of Levels, Curves and Hue/Saturation dialog boxes.

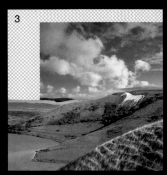

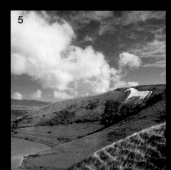

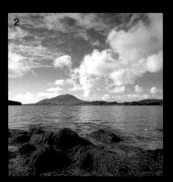

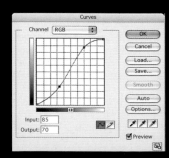

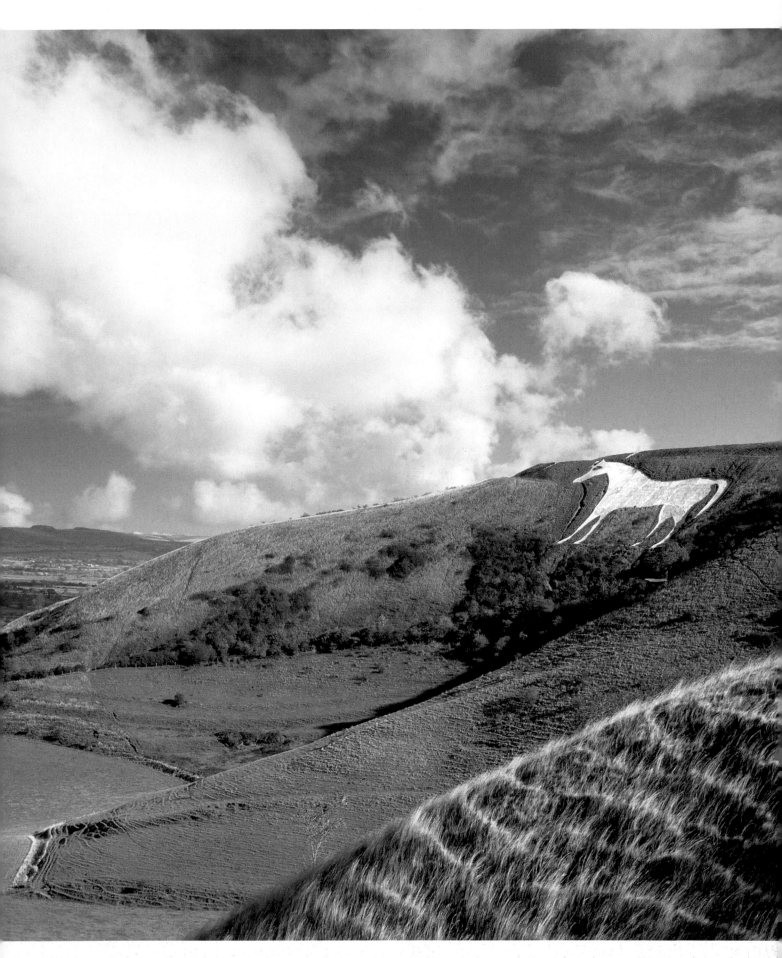

Changing Moods

I took this shot of Whitby Abbey on a very dull and overcast day. As the Abbey has links with Bram Stoker's Dracula, I felt it lent itself to something a little different.

1 Using the Magic Wand tool it was easy to remove the large expanse of sky. Once the main body of the sky had been removed, I cleaned up any leftover patches, such as the areas in windows and arches.

2 For the replacement sky I chose a dramatic sunset shot that had lots of cloud detail, and introduced it on a layer behind the abbey.

3 I decided to change the feel of the image. Using the Hue/Saturation adjustment layer, I turned the entire image blue to give a feeling of night.

4 To enhance the stonework in the ruin I have added contrast and used Photoshop's lighting effect filters to give it a more surreal feeling.

For the final image (opposite), I lightened and darkened parts of the image, such as the gravestones in the foreground, and also removed a lamppost.

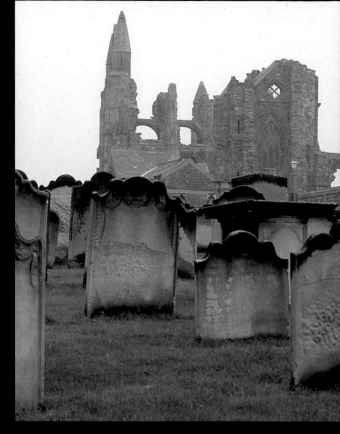

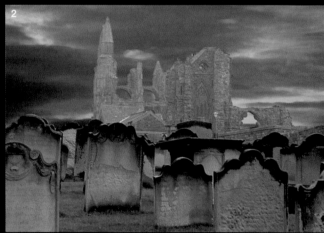

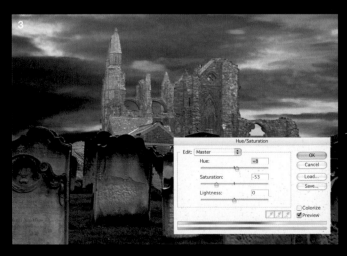

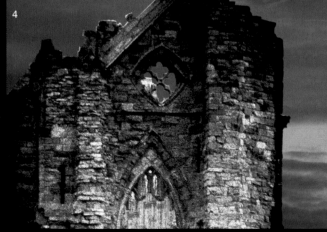

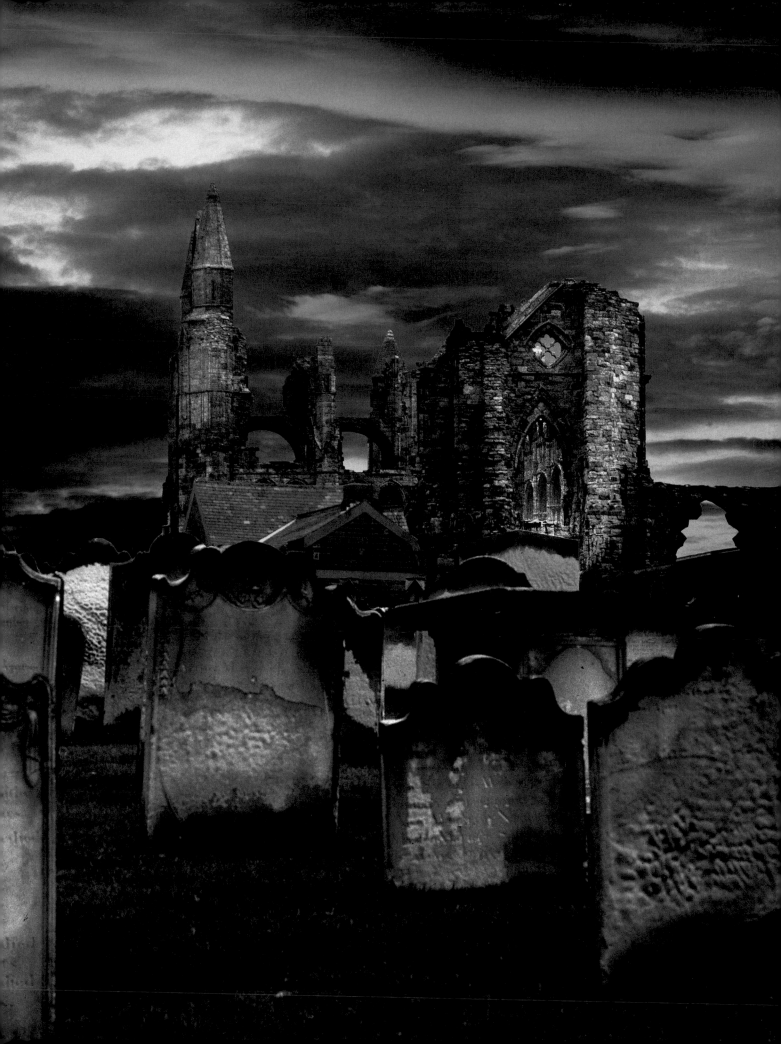

Abstracts

Most of the time, photographers want their photographs to feature instantly recognizable subjects, correctly exposed, composed and printed, but there are a number of very different photographic possibilities that lend themselves to making interesting compositions. These are abstract images, though the original might be a "straight" photograph, but the nature of the subject and/or the way it is presented turns it into a non-representational image. The use of strong areas of colour and a degree of draughtsmanship within their composition gives many of these pictures a "painterly" feel.

An abstract composition can be as simple as a view of a reflection – in water, on an area of wet ground, or in the reflective side of a building or vehicle. When you focus on such a surface and use the auto-focus mechanism, your camera may have difficulty focusing on the reflection and focus on the surface. If this is the case, turn off the auto-focus and focus on the image manually. Another way to make an image abstract is to photograph it out of focus and with minimal depth of field,

again turning off the auto-focus. This method softens the edges of a shot and, depending on the degree of focus, slightly blurs the image, creating an effect of watercolour. Alternatively you might want to choose a slow shutter speed, such as 1/8th second or slower, and zoom the lens while the camera is taking the shot, thereby creating an abstract image.

You could also create an abstract image by photographing a small part of the subject, or cropping in tightly to an existing shot – an area of a building, for example, with strong, geometric lines, or a detail of tension cables and the bolt bosses that hold them. The important aspect of this type of photography is to look at your potential subject from a different perspective. When looking through the camera, slowly zoom in or out from the subject area to see the frame get tighter or wider. When you look at these nuances in the composition carefully, it becomes possible to see the potential of a shot that might not be apparent at first to the naked eye.

Left: The strong lines that run diagonally from top to bottom are details of a ventilation shaft. By placing them in the foreground and focussing on them, the reflected image behind is now out of focus. This draws the eye to the shaft and forms a very strong abstract image.

Below: By selecting a slow shutter speed of 1/8th second, I was able to zoom the lens while taking the shot. This technique creates a strong sense of movement, and can create a stunning image out of mundane surroundings.

Right: This ornamental water feature provided a good opportunity for an abstract image. A fast shutter speed of 1/500th second retained the detail in the water as it splashed on the pebbles. A slower speed would have caused the water to blur, and the impact of the shot would not have been so great.

Below: I photographed this handrail with a 200mm telephoto lens, kept the depth of field to a minimum, focused on the two brackets and let both the foreground and background fall out of focus. I then turned the picture through 90° for the final presentation.

Above and left: These pictures were taken of a building reflected in water. The effects of the wind and current produces an endless variation in the shapes that can be photographed. The abstraction could be taken one step further by printing them as a multiple image (see page 138).

Opposite: The textured metal on the left of this picture is a detail of a sculpture in the City of London. The patterns of light are reflections of the sun bouncing off the windows of a building opposite. The result is an image that has all the qualities of an abstract expressionist painting.

Multiple Images

Multiple exposures are an effective way to extend your creative and compositional repertoire and produce finished shots that are both eye-catching and unusual. Many cameras have the ability to take multiple exposures, or multiple exposures can be created on the computer.

When considering a multiple image, forethought is essential, as you need to plan carefully and decide well in advance exactly where you want each constituent part to be. If you have a camera that allows you to change the focusing screen, you can fit a grid screen, which has vertical and horizontal lines running across it to help you compose your photograph, so you know where to put each shot image.

As well as composition, consideration needs to be given to background and exposure. If your background is mainly light, then your multiple image shot can look washed out and some of the exposures might be difficult to see. Probably the best background is black or at least very dark. When you calculate the exposure for each image, try to keep this even – a multiple-image shot will not look very good if you have two images perfectly exposed but the others over- or underexposed.

Another way of taking multiple exposure shots is to use multiple flash. This does not mean that you need several flash units, rather that you build up your final image with a series of single flashes. In simple terms, this means setting the camera's shutter to B. This will keep it open for as long as the shutter release is depressed. If you are shooting a portrait with your model placed against a black background and the flash fires, say, three times, with your model moving after each flash, three separate images will be recorded on the film or sensor.

Perhaps the easiest way of creating a multiple image is to make a sandwich of two or more pictures. This can be done in the computer with any suitable images that you have downloaded or scanned. Alternatively, you can take a single image and flip it and then print both versions together so that they form a mirror image. By extending this technique, a kaleidoscopic effect can be obtained.

Multiple Faces

Besides making a straight picture sandwich, you can experiment with other effects. Here, having selected the two different faces that I wanted to put together, I cut one at intervals so that it looked as though it was being viewed through a blind. I then enlarged the faces to match each other's proportions and printed both together. At first glance it appears that there is only one face looking out from behind a vertical blind.

Right: Many flashguns have the ability to fire a stroboscopic flash sequence. If you shoot against a black background with no other lighting using this method, you get a multiple exposure, with the moving subject being recorded in a different position every time the flash fires.

Below: This is a simple two-image sandwich. One shot is of a girl lying on a white background, while the other is of a dried sandbank.

Overleaf: For this multiple image I used just one photograph of eroded sandstone. Having made a mirror image of the original shot, I then flipped it and butted the two together. This makes a striking image, which I could have gone on replicating many times to form a kaleidoscopic image.

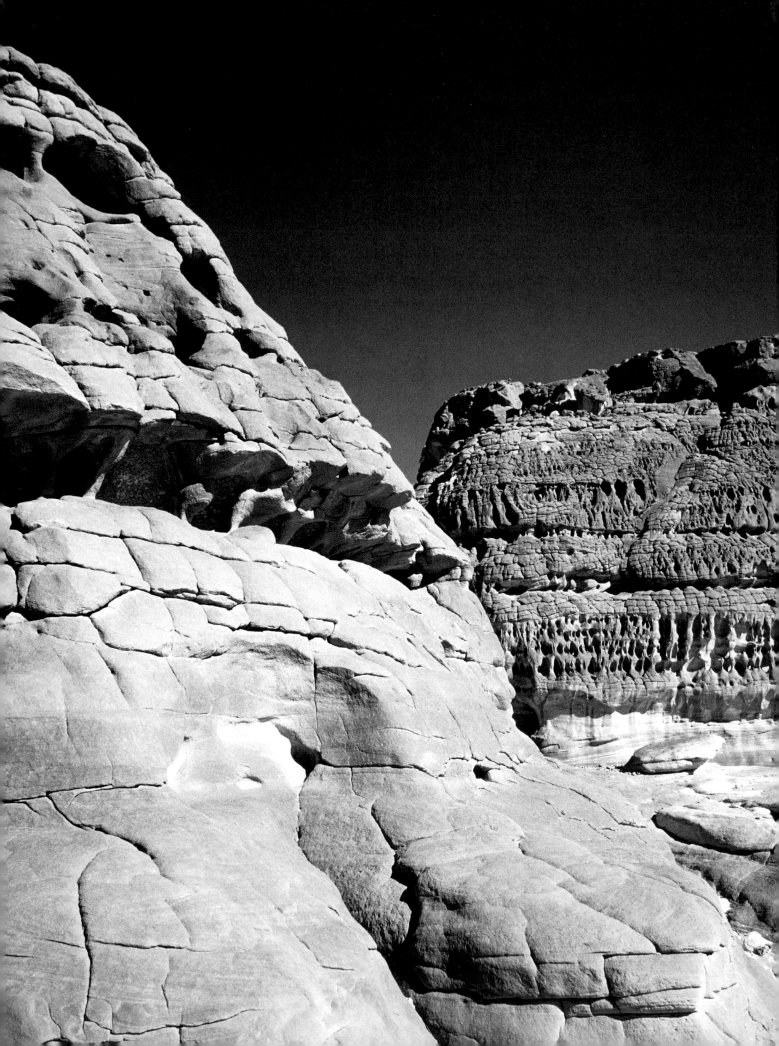

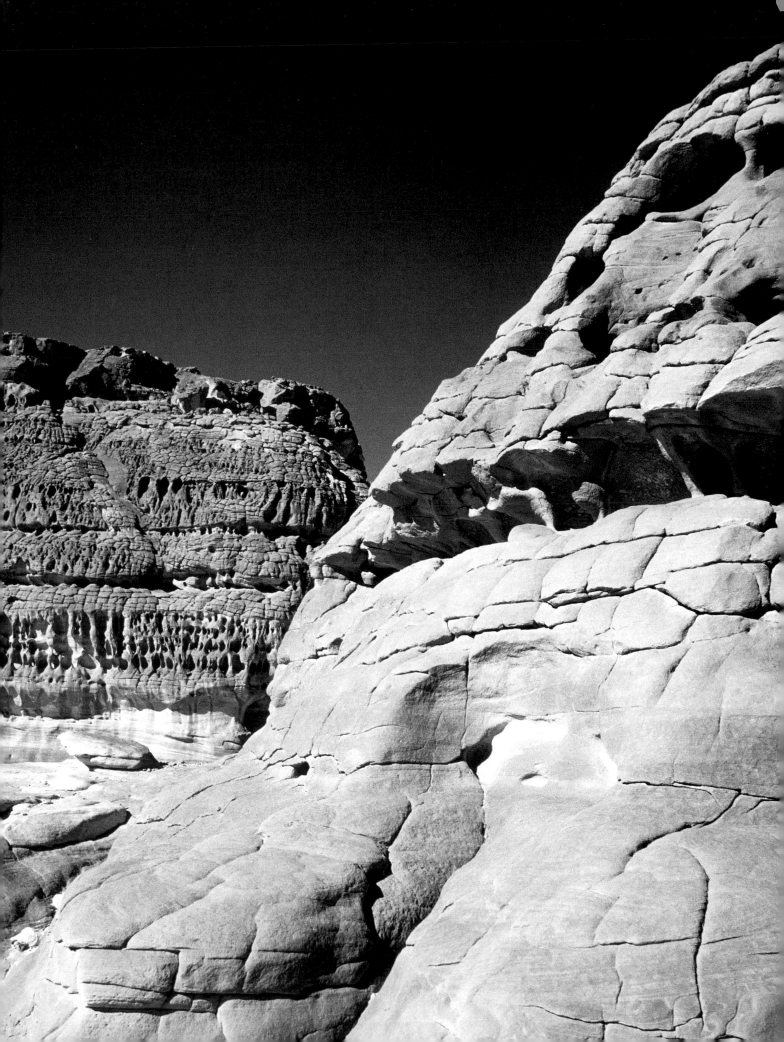

High Contrast

High-contrast images are not to be confused with high-key photographs; in the latter the range of tones in the finished shot is predominantly taken from the light end of the spectrum, while high-contrast photographs are shots where the tones are taken from the extremes of the spectrum, with few, if any, mid-tones.

Creating high-impact images by stripping the original down to the basics, without any tonal range whatsoever, is a common printing technique, which is sometimes referred to as posterization. Its use in advertising has long been recognized as an effective way of catching peoples' attention. The use of image manipulation programmes has made it another tool at the photographer's disposal.

High-contrast pictures can make strong graphic compositions, where the eye is forced to concentrate on specific areas of your shot. When shot in black and white, all tones from the middle area of the greyscale are eliminated, while when working in colour, it is possible to just use one colour contrasted against black or white. Of course, there is the choice of using an infinite amount of other colours, so long as they are just flat colour without any tone.

As in so many cases, a fruitful way to study this technique in photography is to look at paintings, which can be good references for styles and approaches that you might want to adopt. One painter who springs to mind is the late Andy Warhol, who used the high-contrast technique extensively, especially in his silkscreen prints.

In addition to printing such effects in the darkroom, using high-contrast papers and developers, there is now scope to extend the technique further on your computer. A software package, such as Photoshop, enables you to create high-contrast images and then reproduce them with ease. As with so many techniques, however, this type of shot can easily fall into the gimmicky or tacky variety if you allow the technique to become the master of the shot, rather than you becoming the controller of the medium.

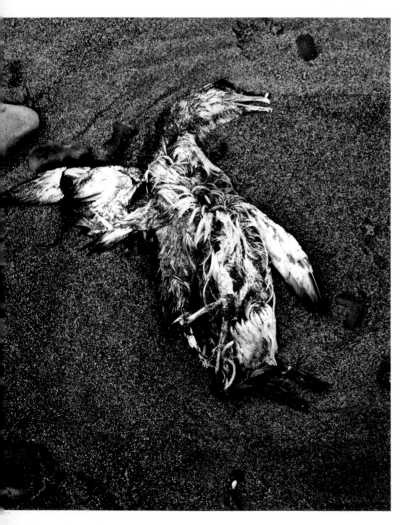

Left: This dead seabird immediately caught my eye while I was walking along a beach. It made an arresting image, but I felt it could be further enhanced by increasing the contrast. As a result, the texture of the sand has taken on a rocky feel and the overall image now has a fossil-like quality.

Opposite: Reducing the tones in this shot of an old sailing barge to virtually zero has produced a striking image that works well as a high-contrast picture. The sea has just the right amount of texture, while the sky, which was dull and overcast at the time of the original shot, is completely devoid of tone.

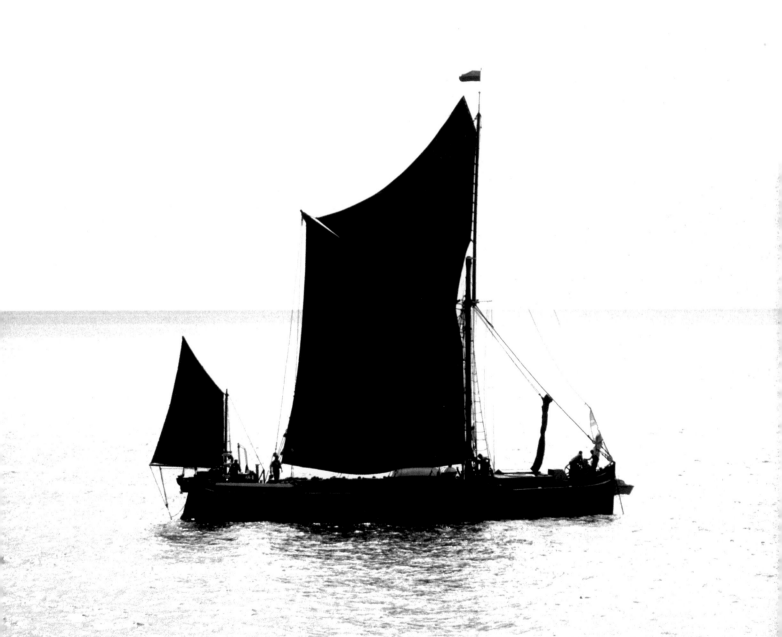

Above: The great thing about experimenting with high-contrast printing is that it can lend itself to many of your existing photographs stored in your library. This girl's eyes appear particularly seductive now that the contrast has been increased and only minimal tones remain.

Close-ups

It is useful to have a macro lens when photographing close-ups, as it enables you to get in closer than is possible with a normal lens. With a macro lens you should be able to shoot a small subject life-size, and if you combine this lens with extension tubes or bellows, both of which are fitted between the lens and the camera body, the magnification can be even greater.

Extension tubes come in various lengths and can be mounted together for extreme magnification – the longer the final set of tubes is, the closer you can get to your subject. However, depending on the combination that you use, the distance of the lens to the subject will be fixed. Extension bellows, on the other hand, have the advantage of variable magnification and allow far more precise framing of your subject at close quarters.

Although the depth of field at these distances may be minimal, it still exists, so if you stop the lens right down and use the maximum depth of field possible, you still need to pay a proper amount of attention to the background – even at these distances, unsightly detail can come into focus and ruin the overall composition.

Another mistake is to think that stopping down to the smallest aperture creates the sharpest shots. All lenses have an optimum aperture for sharp focus: on a lens with an aperture range of f2.8 to f22, depth of field can be at its greatest when using f22. However, the sharpest shot is one taken when the lens is set to f11, because diffraction – the bending or spreading out of light as it passes though a narrow aperture – reduces the overall image definition and resolving power.

Whatever the lens and close-up device you use, it is a distinct advantage to use an SLR camera so that you can see exactly what is happening through the viewfinder. With compact cameras there will be a disparity between what the lens sees and what the viewfinder sees. This is known as parallax error, and you will have to compensate to correct it, otherwise some of your shot will not be included in the frame.

Left: To get this close I used a macro lens with two extension tubes. The focus was at the tip of the stamen, and rather than focusing the lens I moved the whole camera backwards and forwards to get the image sharp. Because I wanted the background to be blurred, I only stopped down to f8. The result is razor-sharp on the stamen, which makes it stand out from the rest of the flower.

Opposite: Going in close on these big anchor chains results in a real sense of strength. The textures show up particularly well. Often the most mundane objects can take on a totally different perspective when they are seen in close-up detail.

Overleaf: These white tulips were backlit by early-morning sunlight coming in through a window. I set the camera on a tripod and positioned two reflectors either side to bounce light back on to them. I kept the depth of field to a minimum, and focused on the tips of the two central flowers.

Presentation

Once you have taken your photographs, you need to consider the best way to present them. Gone are the days when photographs were put into an album or left in wallets and put away to collect dust. On top of that, the photographs probably became separated from the negatives, so that making reprints was only possible by having the original print scanned or copied. Of course there is nothing wrong with mounting your pictures in an album, but even here, there are new ways of presenting them that are far removed from the old methods.

If you are going to present your work in an album, it is now possible to create your own. There are many different "art" papers available that can be used as the leaves in the album with your pictures printed straight onto them. In addition to printing one image to a page, several shots can be printed as a composite on a single page, which gives much more of an editorial feeling and a more professional finish. Not only that, but you can introduce text – which can be anything from a title to personal comments or prose – to the pages.

Another way of displaying your work is in an image-storage system, such as Apple iPhoto or Photoshop. Each shot you take can be placed in the library in separate categories. From these you can edit out a "slide show", to which you can add music or a commentary. This can all be kept on a laptop and be transported easily to show friends or colleagues.

Yet another method is to transfer the images onto DVD. What is great about this is that once the system is set up you can burn an endless amount of DVDs, which can then be sent to family and friends and viewed on their television or computer. Any number of images can be sent electronically by e-mail as JPEGs. Your photographs can also be made into posters, greetings or business cards, or a personal diary of a particular event, such as the first hundred days of a new baby.

If you want to present your shots in the traditional slide-show manner, digital projectors enable you to put shots together as composites, fade from one shot to another, and add a commentary and music, as well as projecting titles and text.

2

1. In addition to producing prints from your photographs, images can be shared with family and friends by being placed on the Web. This could be by e-mail or on your own Web pages, as shown here.

2. Traditional albums still exist, but with the versatility of computer technology, many more exciting ways are available to display your prints. Instead of sticking prints on to pages, you can now create your own pages and print straight onto them, either individually or in composite form.

3. Another form of presentation is to make your own CD or DVDs, where your pictures can be set to music in a slide show. These can also have text or an audio commentary added.

4

4 Having taken your shots, you need to store them – and with digital images, this is relatively easy. Apple's iPhoto is an excellent method that can be tailored to your specific requirements. You can use this method for images shot digitally and downloaded directly into the computer, or for shots taken on film that have been scanned. As a rule of thumb, digital data does not exist unless it is stored in at least two places at the same time, so backing up all your work is essential.

5 The advances in printer technology have been so rapid that it is now possible to produce first-rate images on a variety of different papers, ranging from standard photo quality to fine-art rag papers. If you use archival inks there is no reason why your prints should not have permanence, and they can be displayed in your home or workplace.

6 Having edited your images in a program such as iPhoto, you can project them from your computer using a video projector. A long way from the old style of showing one shot after another, you can fade, show composites, panoramas and so on, all accompanied with music or text.

Glossary

Alpha channel
Extra 8-bit greyscale channel in an image, used for creating masks to isolate part of the image.

Analogue
Continuously variable.

Aperture
A variable opening in the lens determining how much light can pass through the lens on to the film.

Aperture priority
Camera metering mode that allows you to select the aperture, while the camera automatically selects the shutter speed.

Apo lens
Apochromatic. Reduces flare and gives greater accuracy in colour rendition.

APS
Advanced photo system.

ASA
American Standards Association. A series of numbers denoting the speed of a film. Now super-seded by ISO numbers, which are identical.

Auto-focus
Lenses that focus on the chosen subject automatically.

B setting
Setting on the camera's shutter speed dial that will allow the shutter to remain open for as long as the shutter release is depressed.

Back light
Light that is behind your subject and falling on to the front of the camera.

Barn doors
Movable metal plates that can be attached to the front of a studio light to flag unwanted light.

Between the lens shutter
A shutter built into the lens to allow flash synchronization at all shutter speeds.

Bit
A binary digit, either 1 or 0.

Blooming
Halos or streaks visible around bright reflections or light sources in digital pictures.

BMP
A file format for bitmapped files used in Windows.

Boom
An attachment for a studio light that allows the light to be be suspended at a variable distance from the studio stand.

Bracketing
Method of exposing one or more frames either side of the predicted exposure and at slightly different exposures.

Buffer ram
Fast memory chip on a digital camera.

Byte
Computer file size measurement.
1024 bits=1 byte
1024 bytes=1 kilobyte
1024 kilobytes=1 megabyte
1024 megabytes=1 gigabyte

C41
Process primarily for developing colour negative film.

Cable release
An attachment that allows for the smooth operation of the camera's shutter.

Calibration
Means of adjusting screen, scanner, etc, for accurate colour output.

Cassette
A light-tight container that 35mm film comes in.

CC filter
Colour correction filter.

CCD
Charged coupled device. The light sensor found in most digital cameras.

CDR
Recordable CD.

CDS
Cadmium sulphide cell, used in electronic exposure meters.

Centre-weighted
TTL metering system that is biased towards the centre of the frame.

Clip test
Method of cutting off a piece of exposed film and having it processed to judge what the development time should be for the remainder.

CMYK
Cyan, magenta, yellow and black: colour printing method used in inkjet printers.

Colour bit depth
The number of bits used to represent each pixel in an image.

Colour negative film
Colour film that produces a negative from which positive prints can be made.

Colour reversal film
Colour film that produces positive images called transparencies or slides.

Colour temperature
A way of expressing the colour content of a white light source, measured in degrees Kelvin.

Compact flash card
Removable storage media used in digital cameras.

Compression
Various methods used to reduce file size. Often achieved by removing colour data (see JPEG).

Contact sheet
A positive printed sheet of a whole processed film, enabling negatives to be selected for enlargement.

Contrast
Range of tones in an image.

Cross-processing
Method of processing colour film in different developers, i.e. colour reversal film in C41 and colour negative in E6.

Cyan
Blue-green light whose complementary colour is red.

Dark slide
A holder for sheet film used in large-format cameras.

Data
Information used in computing.

Daylight-balanced film
Colour film that is balanced for use in daylight at 5400 degrees Kelvin.

Dedicated flash
Method by which the camera assesses the amount of light required and adjusts flash output accordingly.

Depth of field
The distance in front of the point of focus and beyond that is acceptably sharp.

Dialog box
Window in a computer application where the user can change settings.

Diaphragm
Adjustable blades in the lens determining the aperture size.

Diffuser
Material such as tracing paper placed over the light source to soften the light.

Digital zoom
Digital camera feature that enlarges the central part of the image at the expense of quality.

DIN
Deutsche Industrie Norm. German method of numbering film speed, now superseded by ISO number.

Download
Transfer of information from one piece of computer equipment to another.

DPI
Dots per inch. Describes the resolution of a printed image (see PPI).

DPOF
Digital print order format.

Driver
Software that operates an external device or peripheral device.

DX
Code marking on 35mm film cassettes that tells the camera the film speed, etc.

E6
Process for developing colour reversal film.

Emulsion
The light-sensitive side of film.

EV
Exposure value.

EVF
Electronic viewfinder found in top-quality digital cameras.

Exposure meter
Instrument that measures the amount of light falling on the subject.

Extension bellows
Attachment that enables the lens to focus at a closer distance than normal.

Extension tubes
Attachments that fit between the camera and the lens that allow close-up photography.

F numbers
Also known as stops. They refer to the aperture setting of the lens.

File format
Method of storing information in a computer file, such as JPEG, TIFF, etc.

Film Speed
See ISO.

Filter
Device fitted over or behind the camera lens to correct or enhance the final photograph.

Filter factor
The amount of exposure increase required to compensate for a particular filter.

Firewire™
High-speed data transfer device up to 800 mbps (mega bits per second), also known as IEEE 1394.

Fish-eye lens
A lens that has an angle of view of 180 degrees.

Fixed focus
A lens whose focusing cannot be adjusted.

Flag
A piece of material used to stop light spill.

Flare
Effect of light entering the lens and ruining the photograph.

Flash memory
Fast memory chip that retains all its data, even when the power supply is switched off.

Focal plane shutter
Shutter system that uses blinds close to the focal plane.

Fresnel lens
Condenser lens that aids focusing.

Fringe
Unwanted border of extra pixels around a selection caused by the lack of a hard edge.

Gel
Coloured material that can be placed over lights either for a special effect or to colour correct or balance.

Gobo
A card used in front of a spotlight to create different patterns of light.

Grain
Exposed and developed silver halides that form grains of black metallic silver.

Greyscale
Image that comprises 256 shades of grey.

Hard drive
Computer's internal permanent storage system.

High key

Photographs in which most of the tones are taken from the light end of the scale.

Histogram

Diagram in which columns represent frequencies of various ranges of values of a quantity.

HMI

Continuous flicker-free light source balanced to daylight.

Hot shoe

Device usually mounted on the top of the camera for attaching accessories such as flashguns.

Incident light reading

Method of reading the exposure required by measuring the light falling on the subject.

Internal storage

Built-in memory found on some digital cameras.

Interpolation

Increasing the number of pixels in an image.

Invercone

Attachment placed over the exposure meter for taking incident light readings.

ISO

International Standards Organization. Rating used for film speed.

Jaggies

Images where individual pixels are visible due to low resolution.

JPEG

A file format for storing digital photographs where the original image is compressed to a fraction of its original size.

Kelvin

Unit of absolute temperature used in photography to express colour temperature.

Latitude

Usable film tolerance that is greater with negative film than reversal film.

LCD

Liquid crystal display screen.

Light box

A light with a diffused screen used for viewing colour transparencies.

Low key

Photographs in which most of the tones are taken from the dark end of the scale.

Macro lens

A lens that enables you to take close-up photographs.

Magenta

Complementary colour to green, formed by a mixture of red and blue light.

Megapixel

1,000,000 pixels.

Mirror lock

A device available on some SLR cameras that allows you to lock the mirror in the up position before taking your shot to minimize vibration.

Moiré

An interference pattern similar to the clouded appearance of watered silk.

Monobloc

Flash unit with the power pack built into the head.

Montage

Image formed from a number of different photographs.

Morphing

Special effect where one image changes into another.

Network

Group of computers linked by cable or wireless system so they can share files. The most common form is ethernet. The Web is a huge network.

Neutral density filter

A filter that can be placed over the lens or light source to reduce the required exposure.

Noise

In digital photography, an effect that occurs in low light that looks like grain.

Pan tilt head

Accessory placed on the top of a tripod that allows smooth camera movements in a variety of directions.

Panning

Method of moving the camera in line with a fast-moving subject to create the feeling of speed.

Parallax correction

Movement necessary to eliminate the difference between what the viewfinder sees and what the camera lens sees.

PC card

Removable memory cards that have been superseded by flash cards.

PC lens

Perspective control or shift lens used to correct distortion, mainly in architectural photography.

Photoshop

Image manipulation package that is the industry standard.

Pixel

The element that a digitized image is made up from.

Polarizing filter

A filter that darkens blue skies and cuts out unwanted reflections.

PPI

Pixels per inch. A measurement of image resolution that defines the size the image can be printed.

Predictive focus

Method of auto-focus that tracks a chosen subject, keeping it continuously sharp.

Prop

An item included in a photograph that enhances the final composition.

Pulling

Decreasing the development of the film.

Pushing

Rating the film at a higher ISO and then increasing the development time.

RAM

Random access memory.

Rangefinder Camera
A camera that uses a system that allows sharp focusing of a subject by aligning two images in the camera's viewfinder.

Reciprocity failure
The condition where, at slow shutter speeds, the given ISO does not relate to the increase in shutter speed.

Resolution
The measure of the amount of pixels in an image.

RGB
Red, green and blue, which digital cameras use to represent the colour spectrum.

Ring flash
A flash unit in which the tube fits around the camera lens, giving almost shadowless lighting.

ROM
Read-only memory.

Shift and tilt lens
Lens that allows you to shift its axis to control perspective and tilt to control the plane of sharp focus.

Shutter
Means of controlling the amount of time that light is allowed to pass through the lens onto the film.

Shutter priority
Metering system in the camera that allows the photographer to set the shutter speed while the camera sets the aperture automatically.

Slave unit
Device for synchronizing one flash unit with another.

SLR
Single lens reflex camera.

SmartMedia
Type of removable memory used by some digital camera manufacturers.

Snoot
Lighting attachment that enables a beam of light to be concentrated in a small circle.

Spill
Lighting attachment for controlling the spread of light.

Spot meter
A reflected-light exposure meter that gives a reading over a very small area.

Step wedge
A greyscale that ranges from white to black through various shades of grey.

Stop
Aperture setting on a lens.

T setting
Used for long time exposures to save draining the camera's battery.

Teleconverter
Device that fits between the camera and lens to extend the lens' focal length.

TIFF
Tagged inventory file format. The standard way to store digital images.

TLR
Twin lens reflex camera.

TTL
Through-the-lens exposure metering system.

Tungsten-balanced film
Film balanced for tungsten light to give correct colour rendition.

TWAIN
Industry standard for image acquisition devices.

USB
Universal serial bus. Industry standard connector for attaching peripherals with data transfer rates up to 450 mbps (mega bits per second).

Vignetting
A darkening of the corners of the frame if a device such as a lens hood or filter is used that is too small for the angle of view of the lens.

White balance
Method used in digital cameras for accurately recording the correct colours in different light sources.

ZIP
An external storage device that accepts files between 100 and 750 megabytes.

Zoom lens
Lens whose focal length is variable.

Index

Acknowledgements

John Freeman and Chrysalis Books would like to thank Calumet Photographic UK for their assistance in the production of this book, and Hasselblad UK for supplying equipment.

This book would not have been possible without the help of many people. In particular I would like to thank Alex Dow, without whom there would be no book! His dedication to the project and technical expertise, especially in the area of digital photography, cannot be spoken of highly enough. I would also like to thank Serena Webb, my project editor, who made it happen on time, Emma Baxter, my commissioning editor and Ian Kearey, my copy-editor; Peter Dawson and Paul Palmer-Edwards at Grade Design for the design concept; Jon Anderson and Brenda Lally for organizing the loan and purchase of equipment from Calumet Photographic; Teresa Neenan for faultless travel arrangements through Trailfinders; Mara Amats; Peter Brooke-Ball; Daz Crawford; Silke Davies; Gil Patrick-Devlin; Debbie Frankham; the staff and pupils at Jubilee Primary School; Katie and Luke Freeman; Emma Hitchcock; Nathan Long; Simon Lycett; Vincent Maillard; Natalie Miller; Helen Moody; Lisa Moore; Kate Miller; Mika; Vania Neves; Martha and Oscar North; Patrick O'Reilly; Reine Sammut; Abigail Toyne; Jody Trew; Fam Van de Heyning; Jennifer Young; and a special thank you to Vanessa Freeman, for being there when it mattered most.

Calumet John Freeman Photography Prize

Here is a fantastic opportunity to win £500 of photography equipment, courtesy of Calumet, plus the complete *The Photographer's Guide to...* series by John Freeman. Applications are welcome from amateur or semi-professional photographers. The winner will be chosen by John Freeman.

First Prize: £500 worth of photography equipment plus a complete set of *The Photographer's Guide to...* series by John Freeman.

10 Runner-up Prizes: Signed copy of *The Photographer's Guide to Portraits* by John Freeman.

For more information and to download the application form please visit:

www.chrysalisbooks.co.uk
www.calumetphoto.com

Only print photographs will be accepted, accompanied by a completed application form. The closing date for entries is 1st March 2005.